HALLOWEEN BY SIMI

SIMI RAGHAVAN

This book belongs to

Copyright © 2017 Simi Raghavan

All rights reserved. No part of this book may be reproduced or transmitted in any form, by any means, electronic or mechanical, including photocopying, scanning and recording, or by any information storage and retrieval system, without permission in writing from the creator.

ISBN: 1537508563
ISBN-13: 978-1537508566

Welcome colorists to the world of witches, pumpkins & halloween treats.
I am Simi, a self taught artist and this is my first coloring book. I had great fun creating each image in this book and I hope you will have fun coloring them too.

Thank you for choosing my work. Do leave a review for me on amazon & my facebook page & don't forget to post your colored pages on my facebook group. I would love to see how you have used your creativity in making these images come alive with colors.

Check out my website simiraghavan.com for free coloring pages
& join my mailing list for news of exciting offers!

www.simiraghavan.com
amazon.com/author/simiraghavan
facebook.com/simiraghavanart
facebook.com/groups/simiraghavan
simiraghavanart@gmail.com

Other books by Artist Simi Raghavan:

Meditative Mandalas by Simi
Available on:
www.amazon.com/dp/1542355079
PDF: https://gum.co/meditativemandalasbysimi

Fairyland Christmas by Simi
Available on:
www.amazon.com/dp/1534995420/
PDF: https://gum.co/fairylandchristmasbysimi

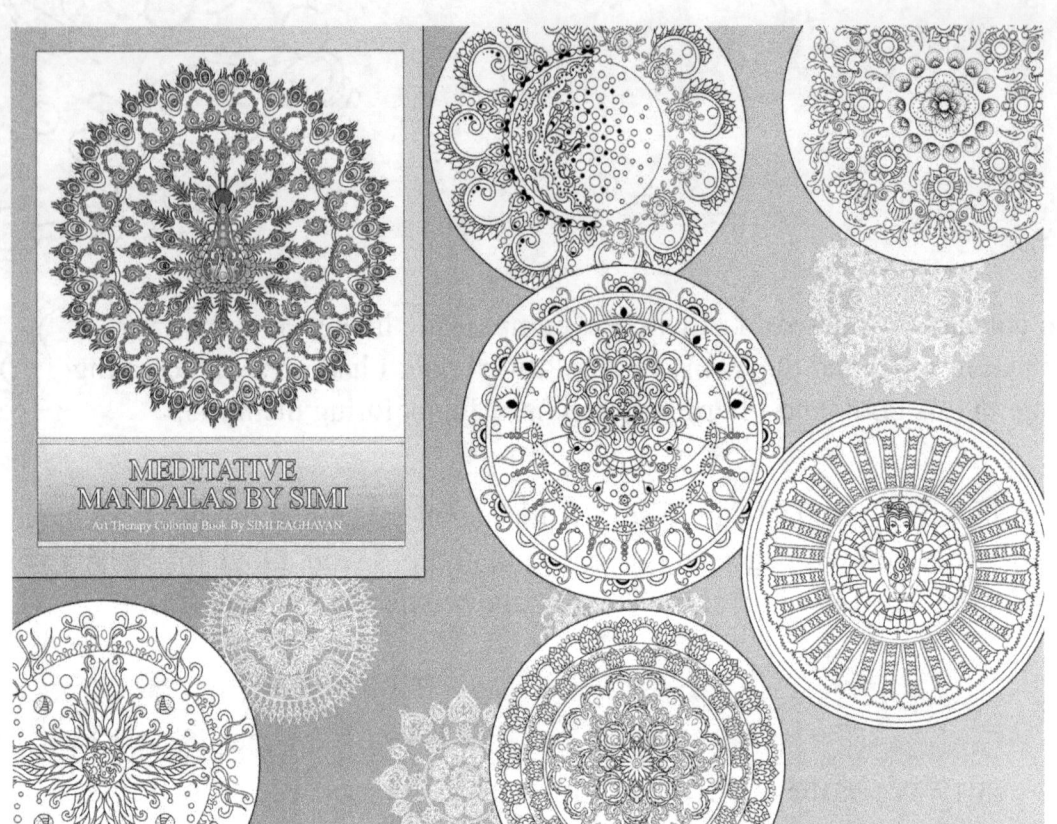

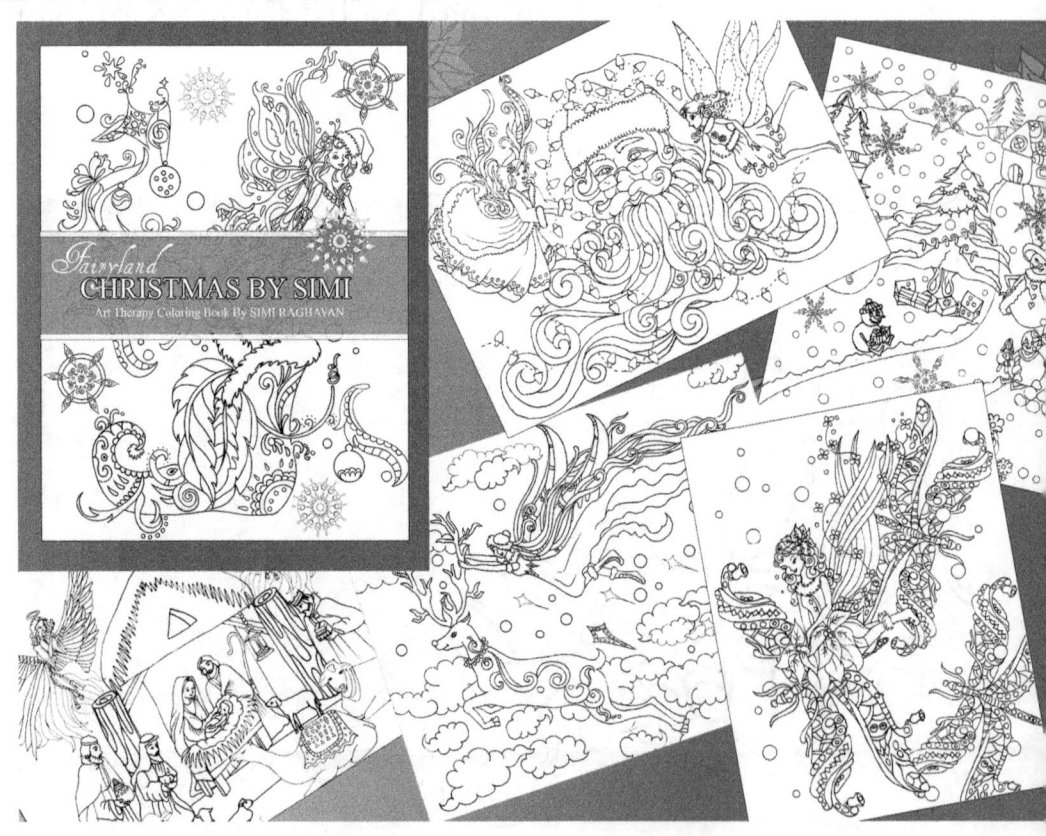

Feel free to test out your colors here.

Use sticky notes to stick on numbers inside the Halloween countdown page.

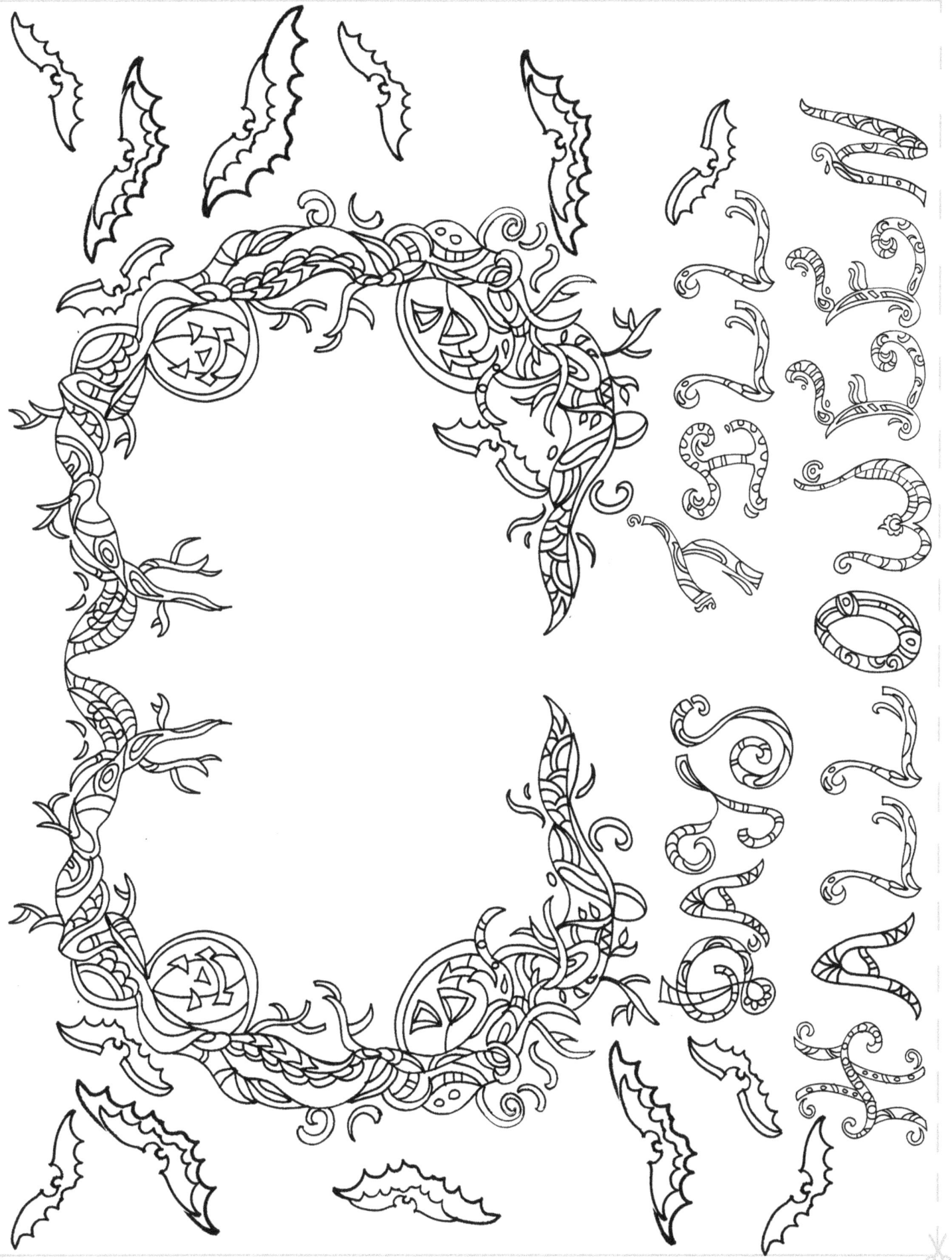

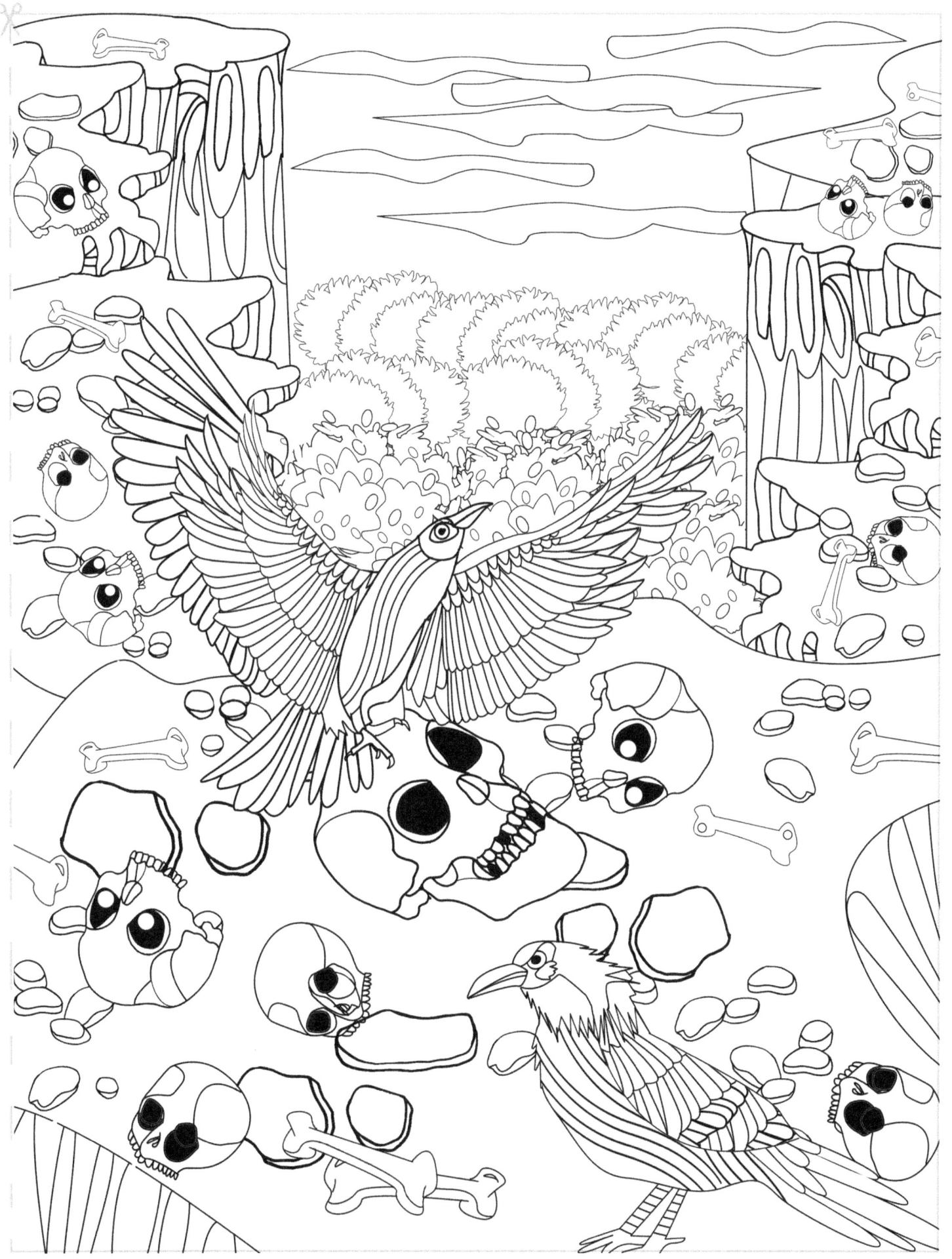

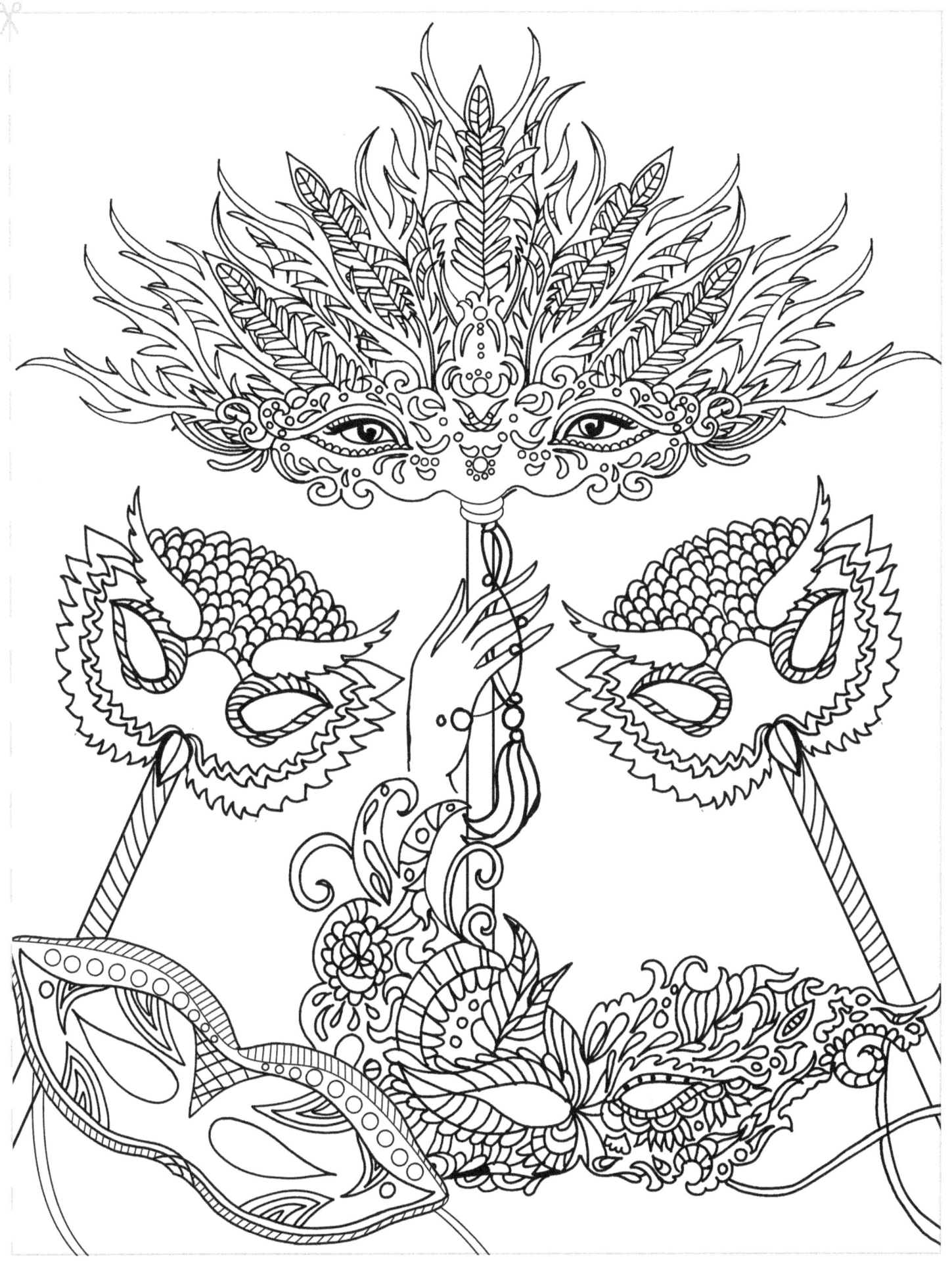

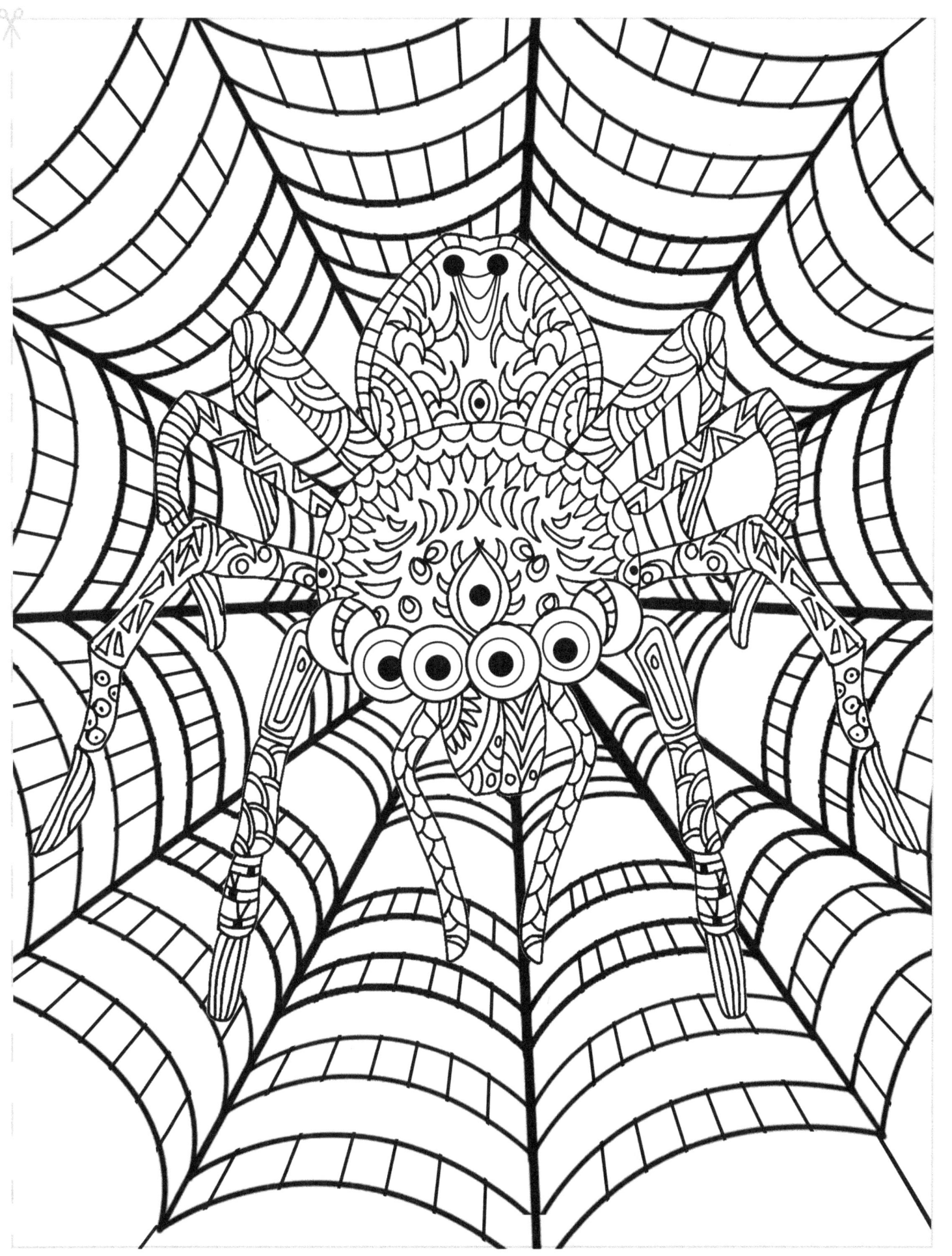

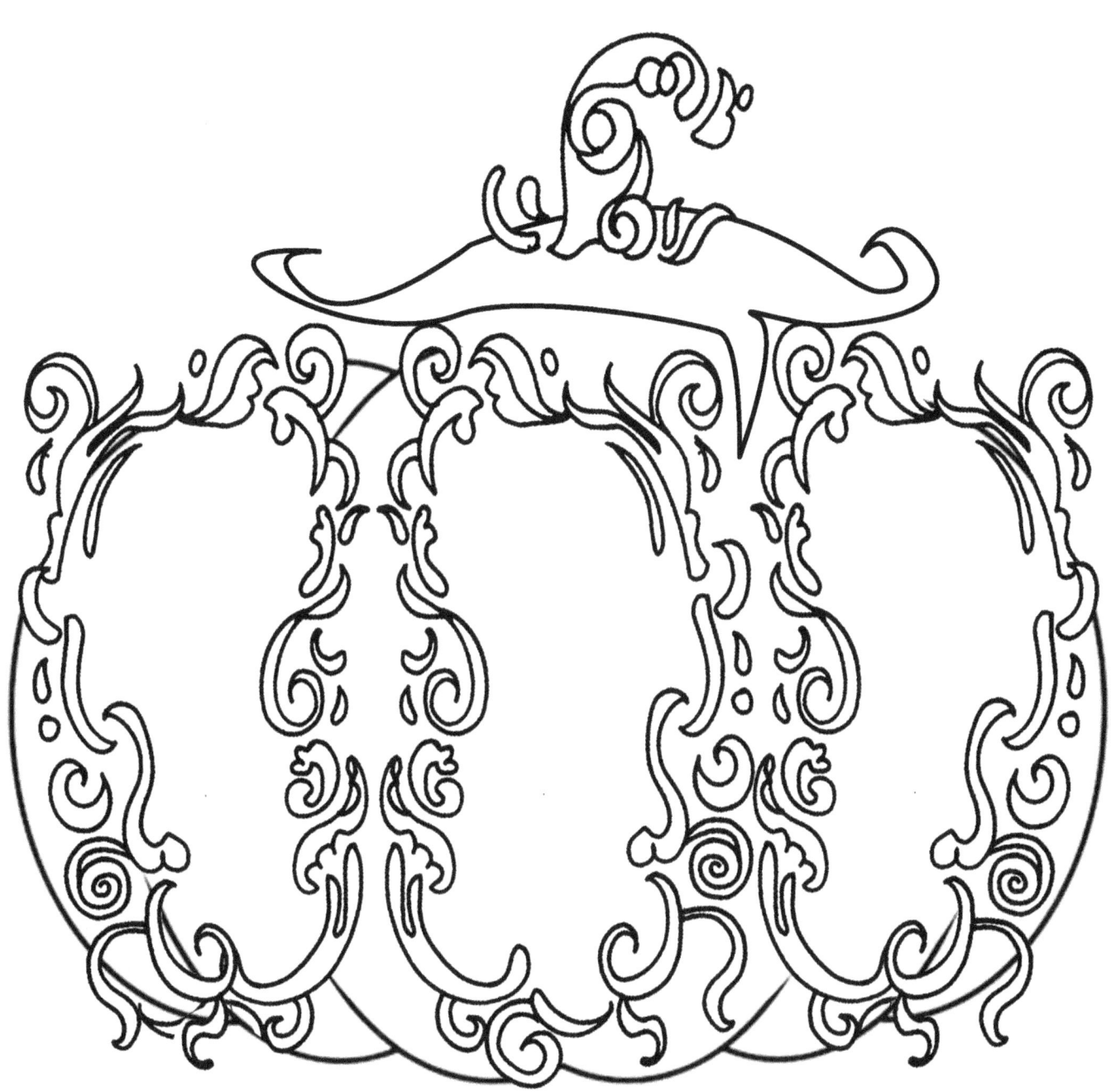

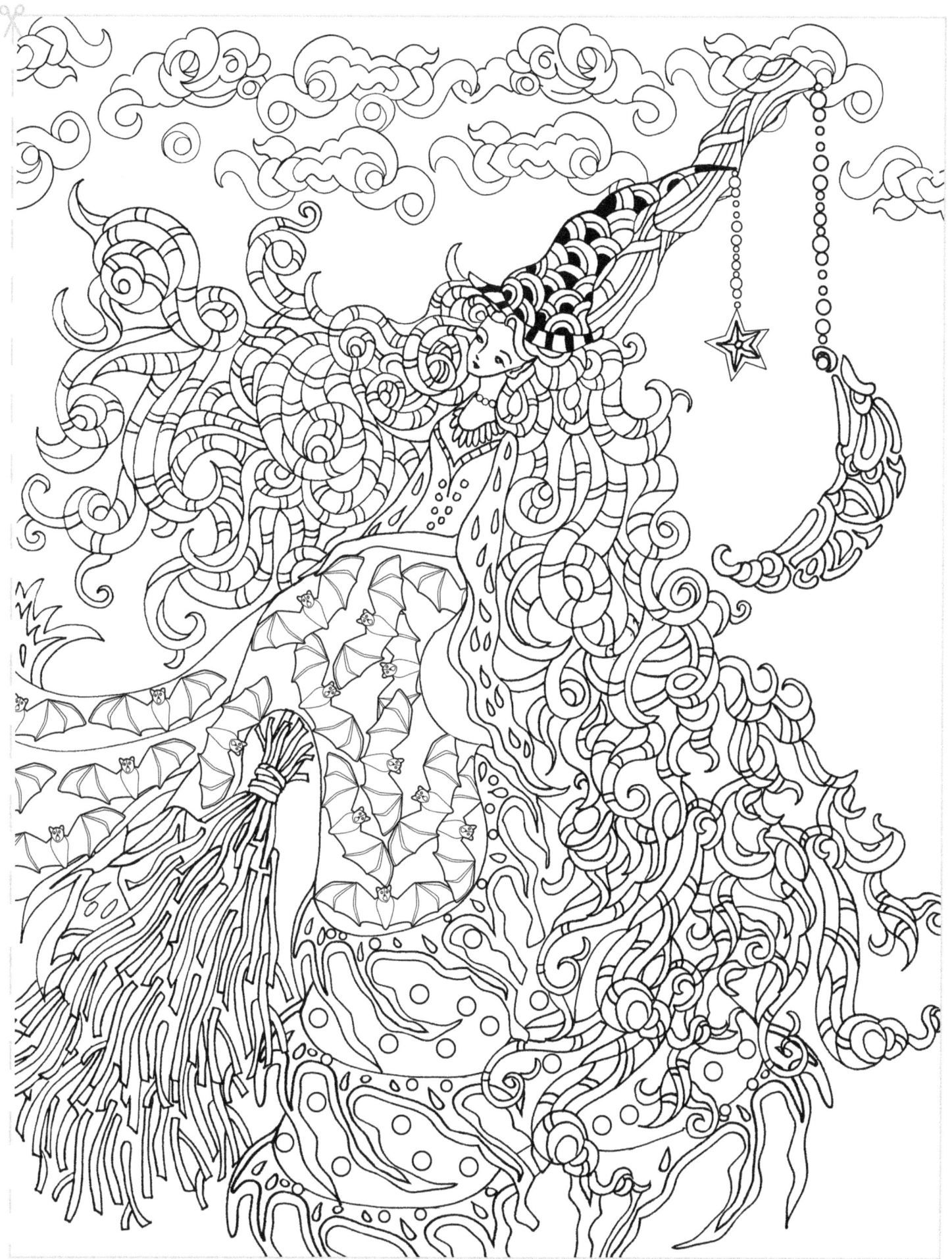

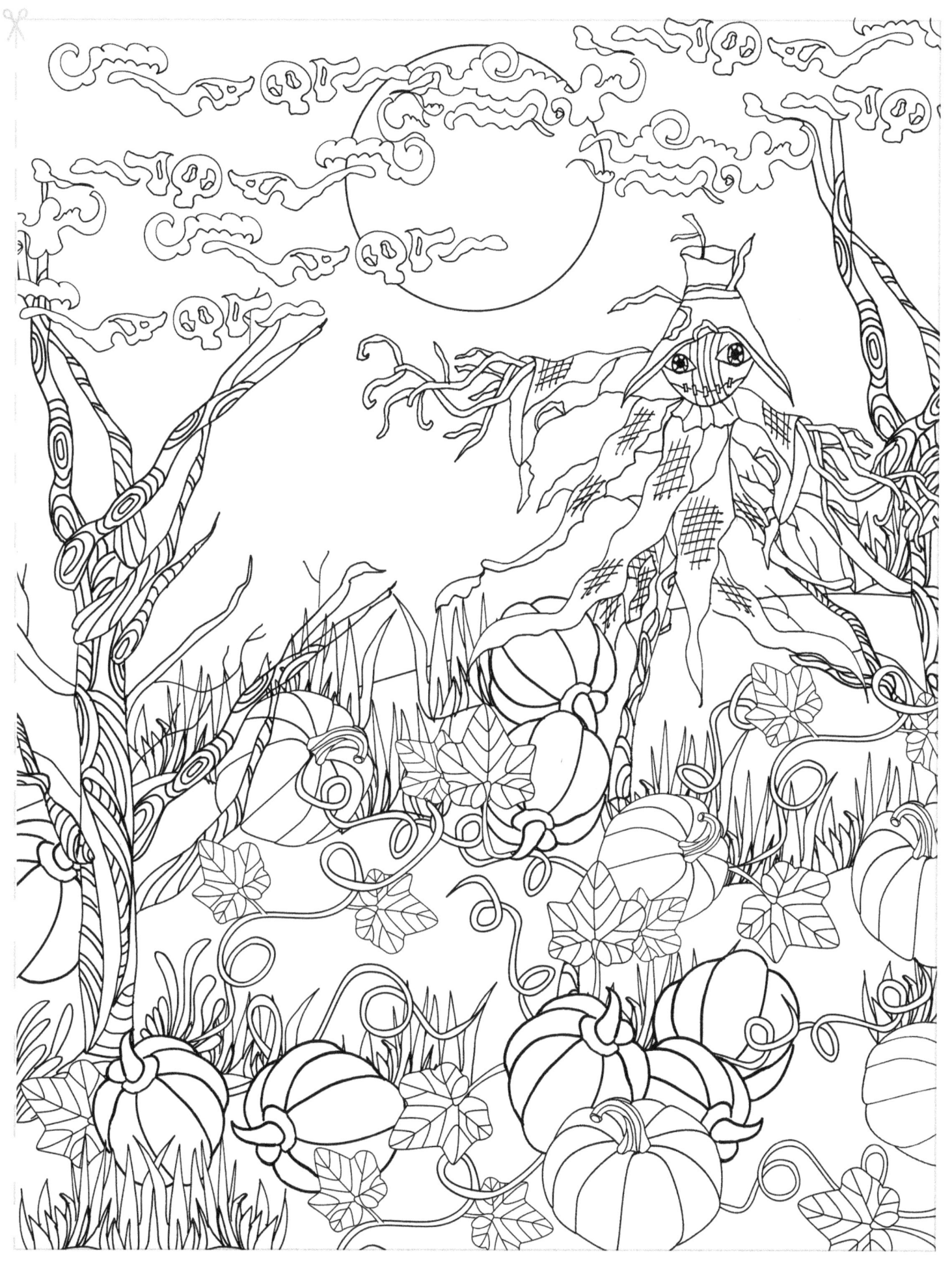

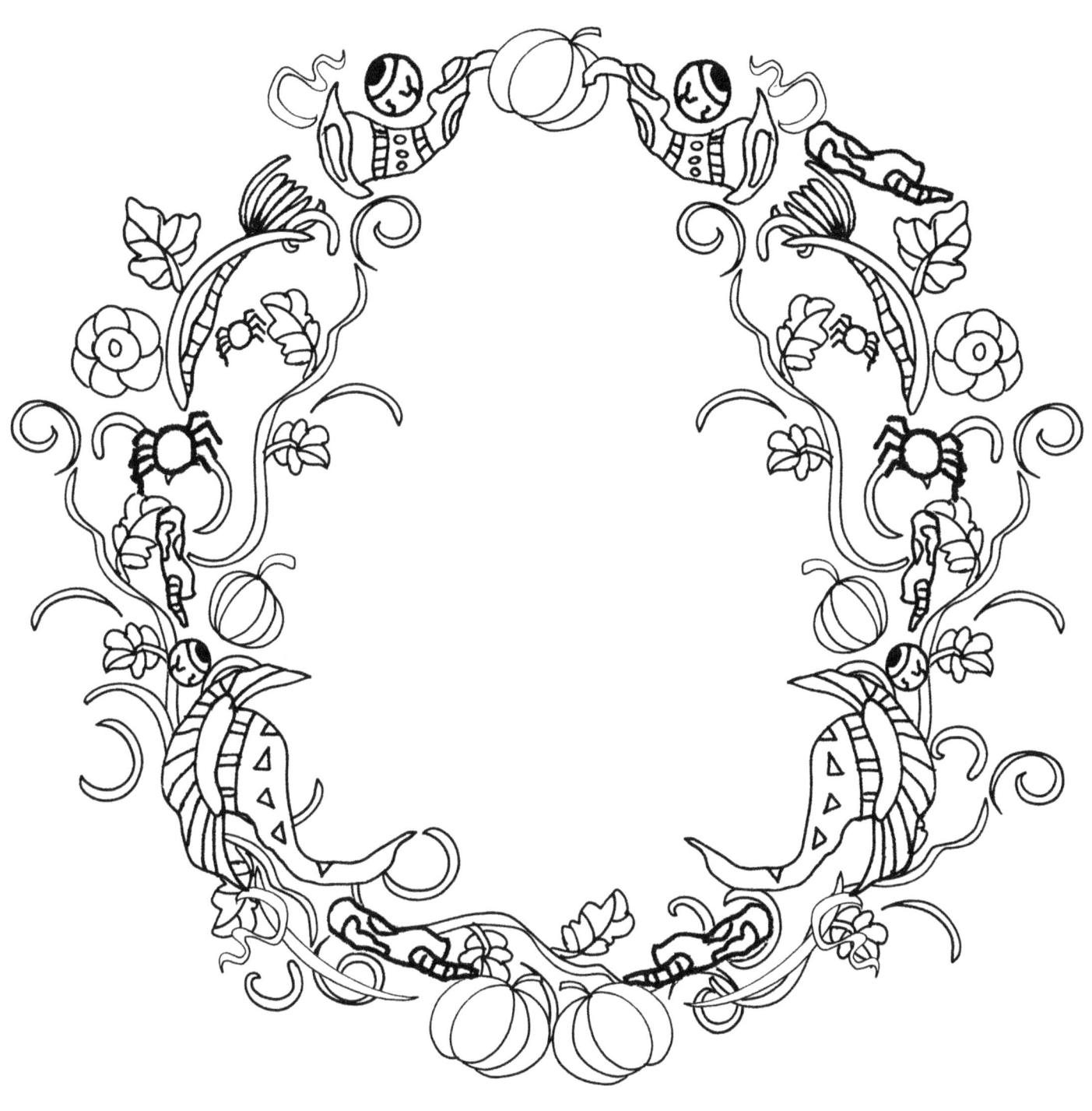

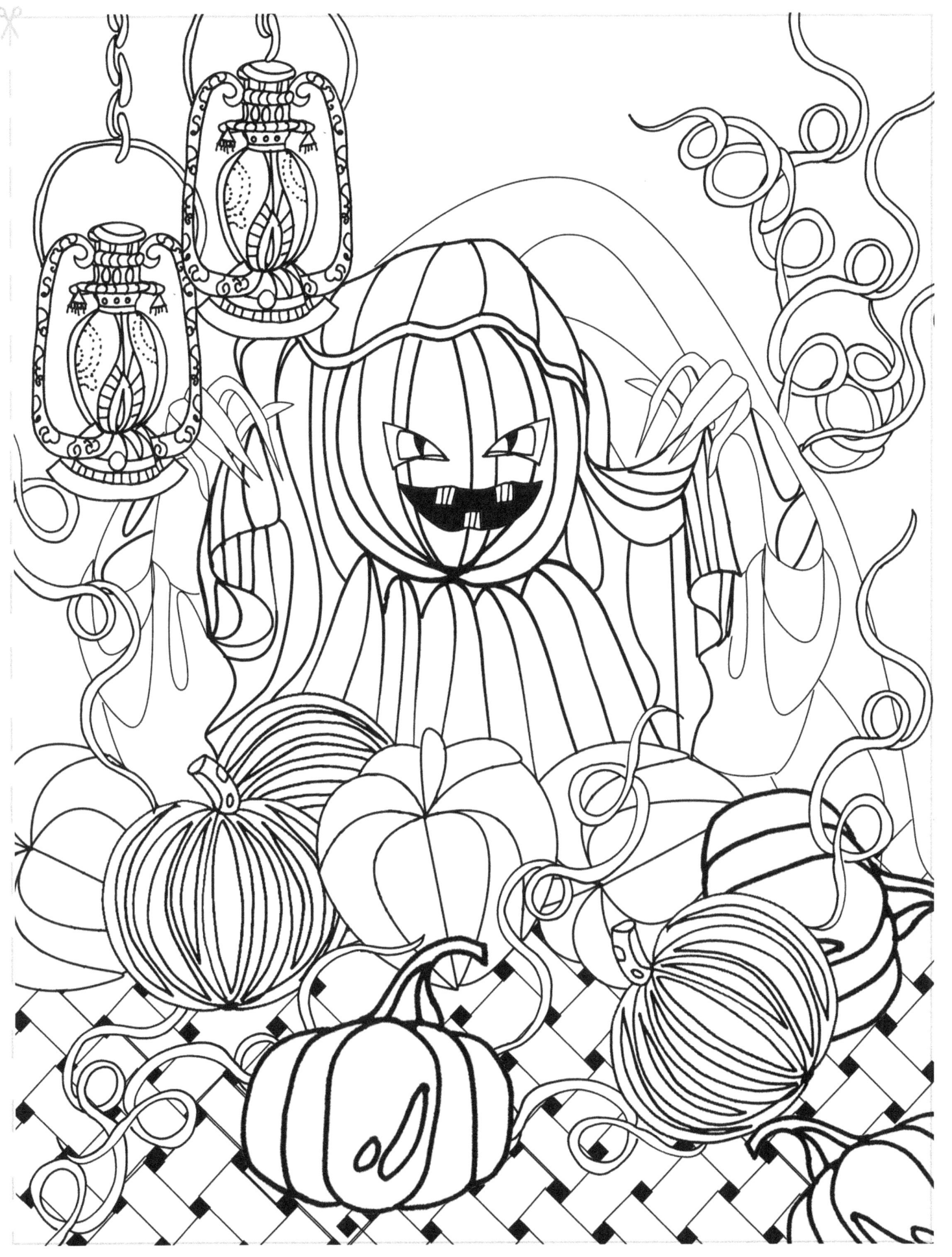

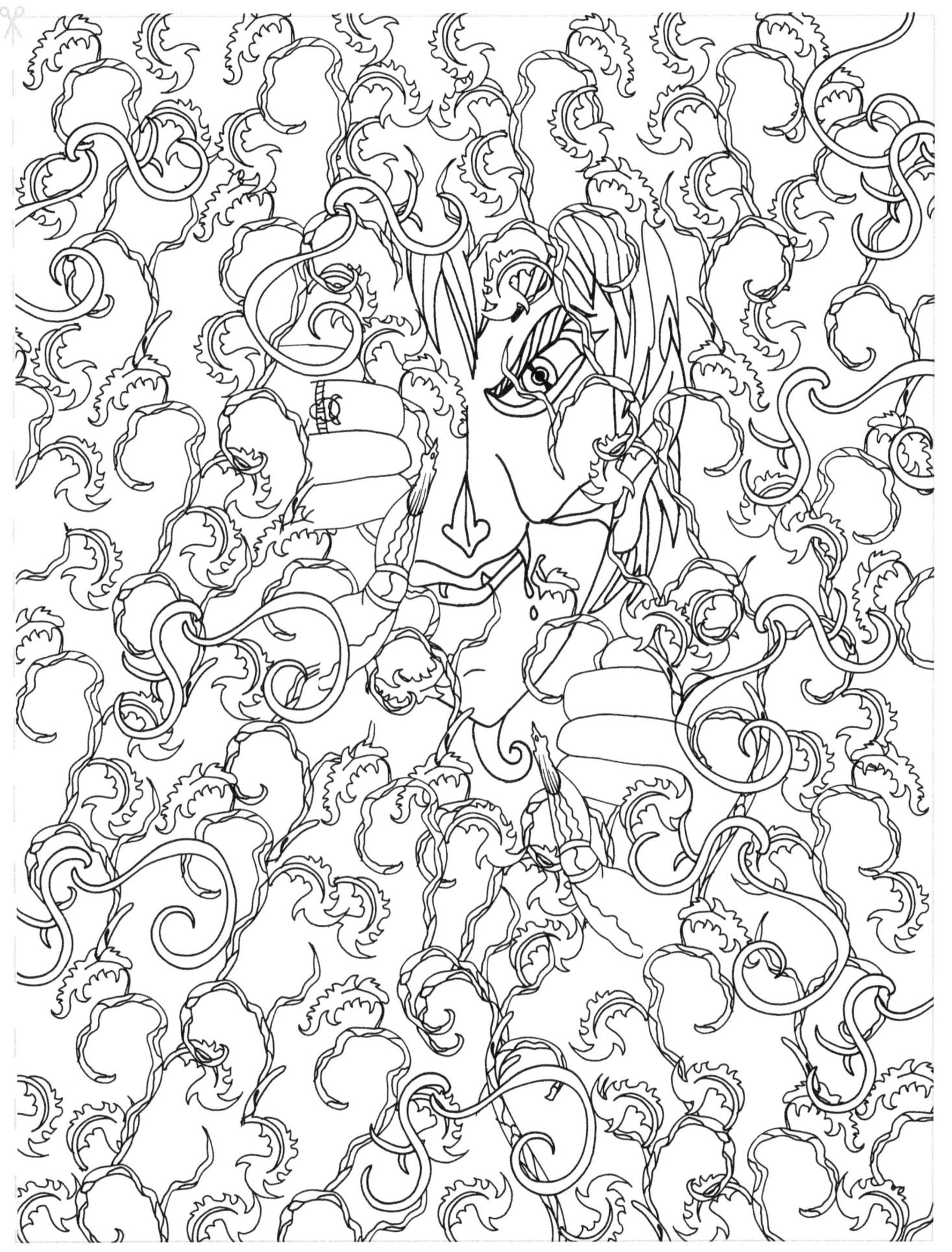

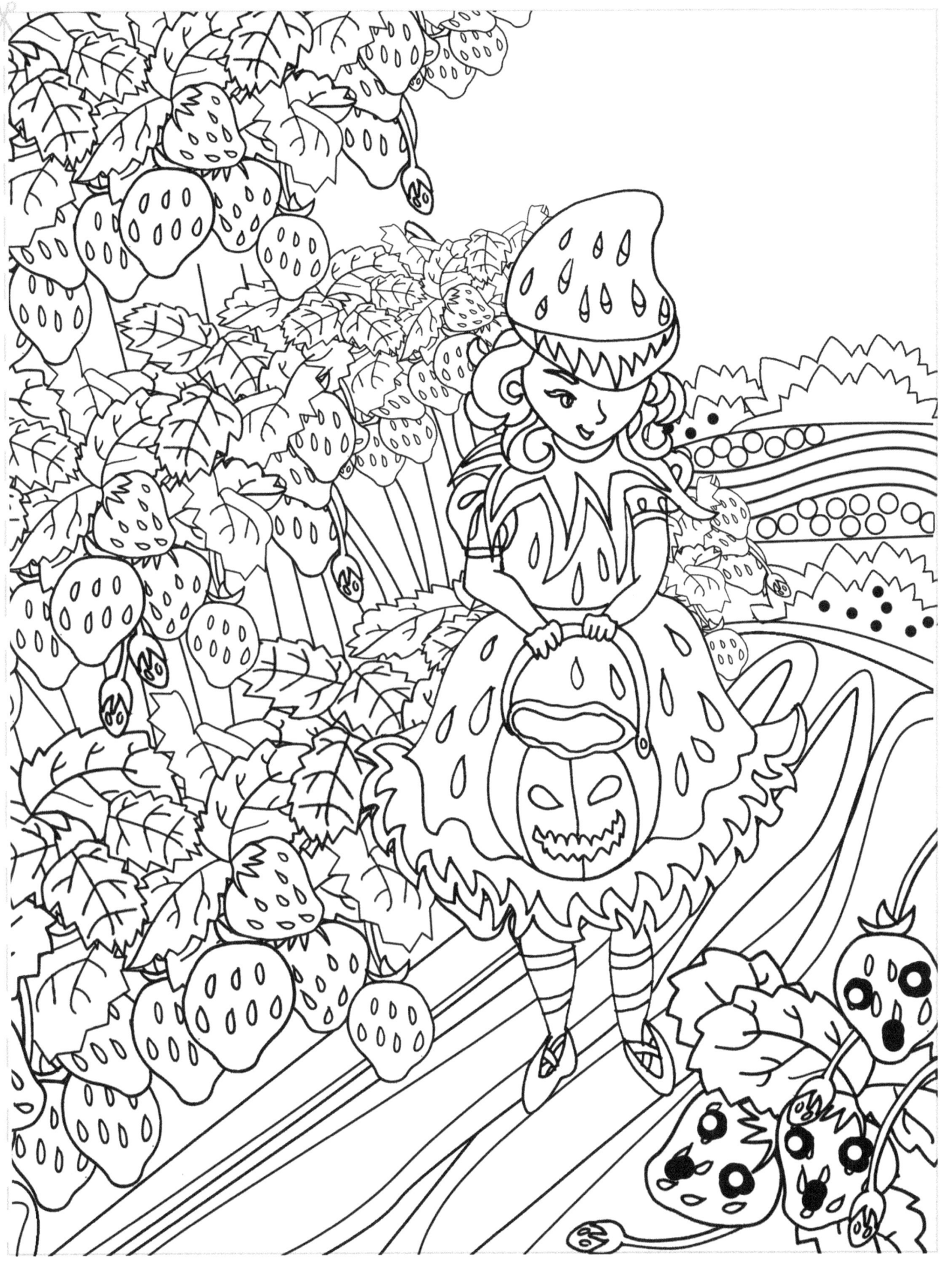

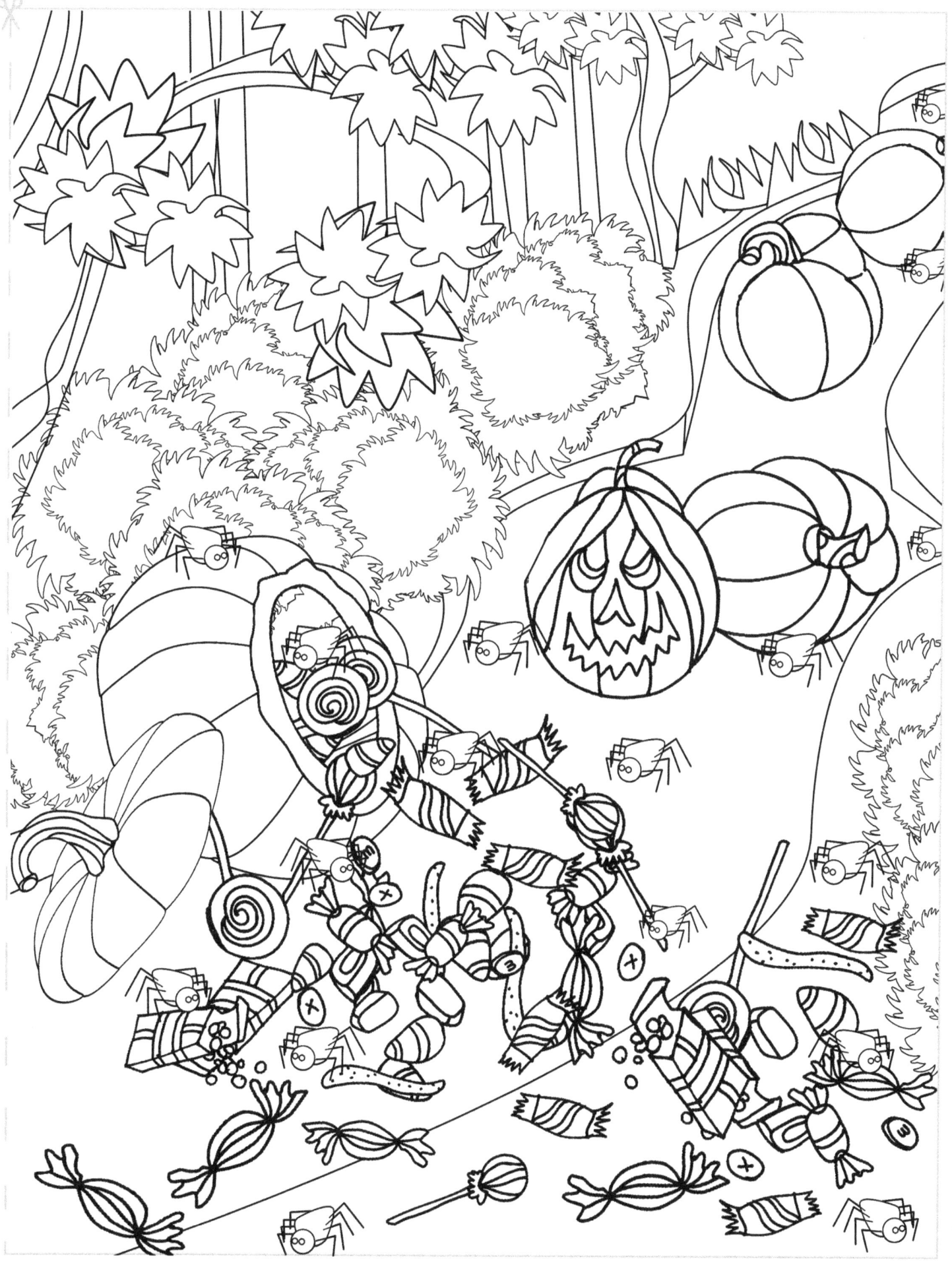

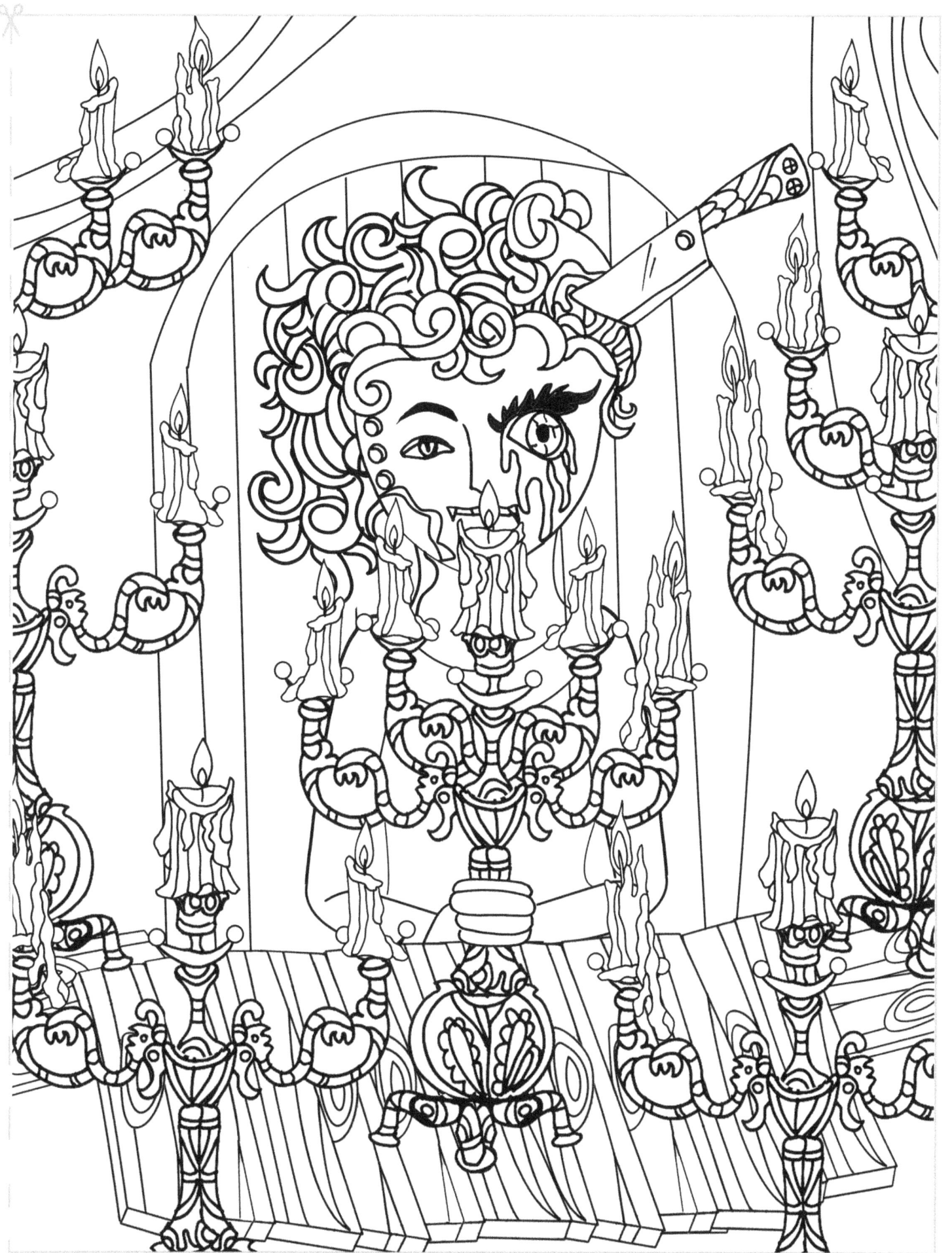

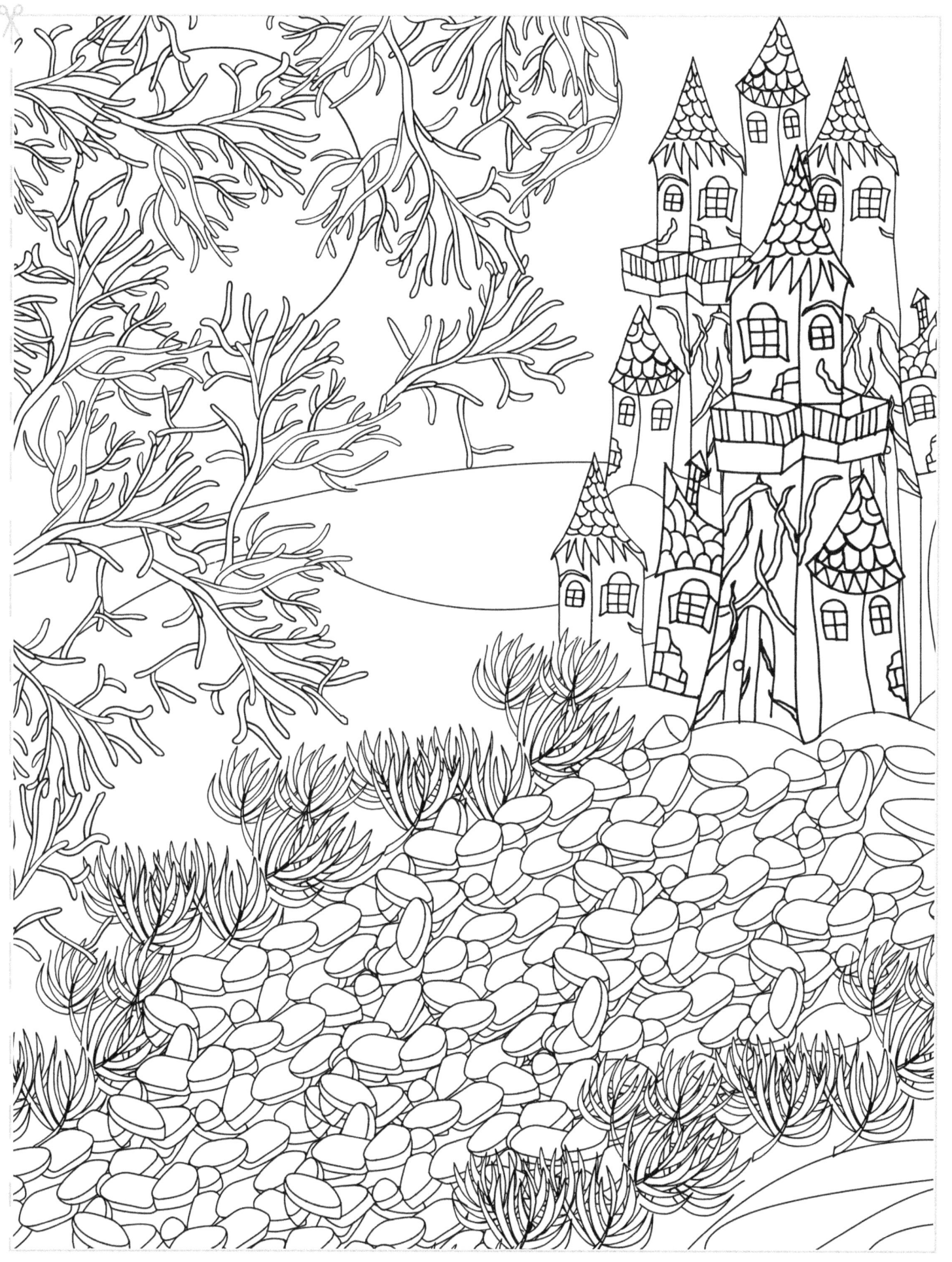

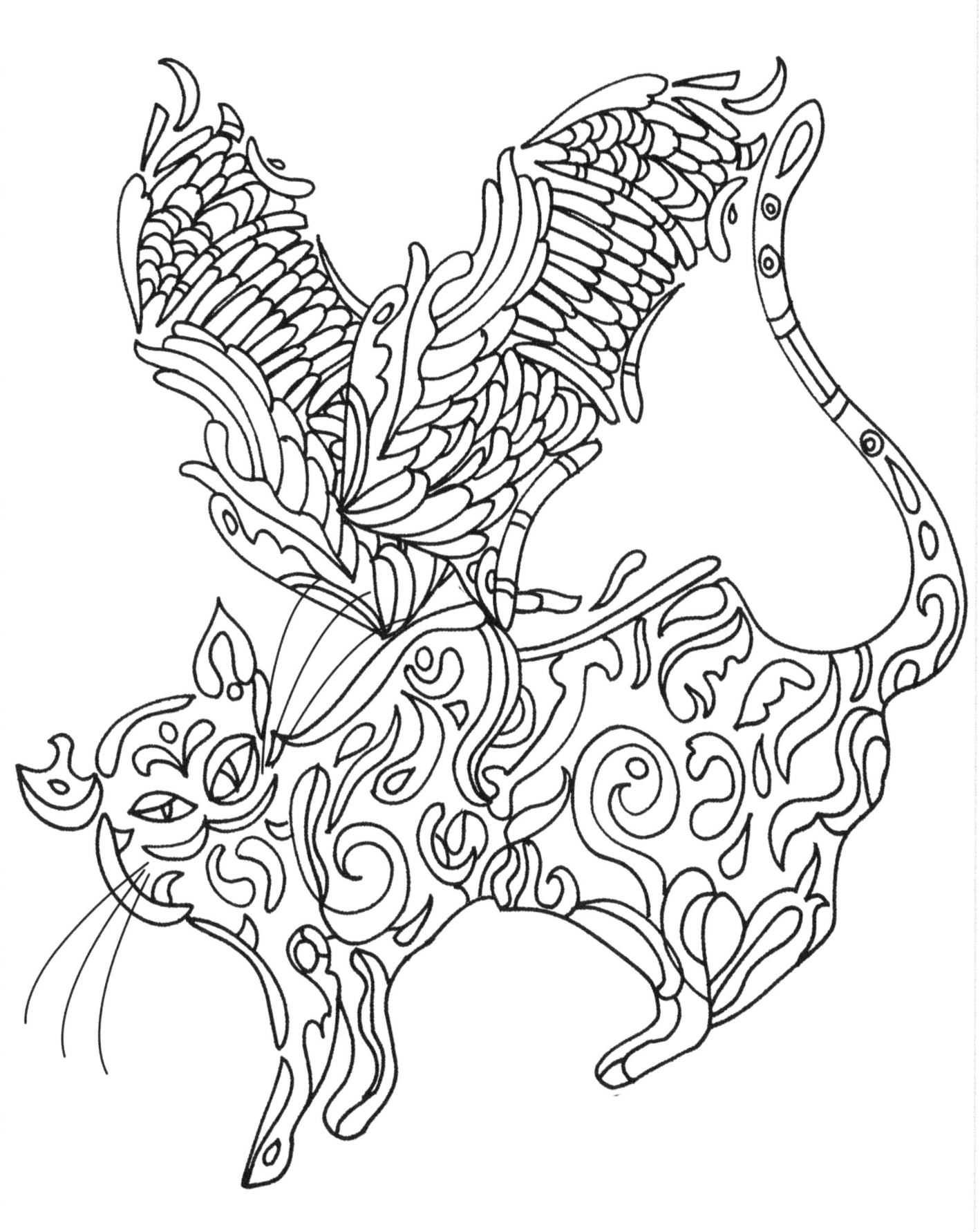

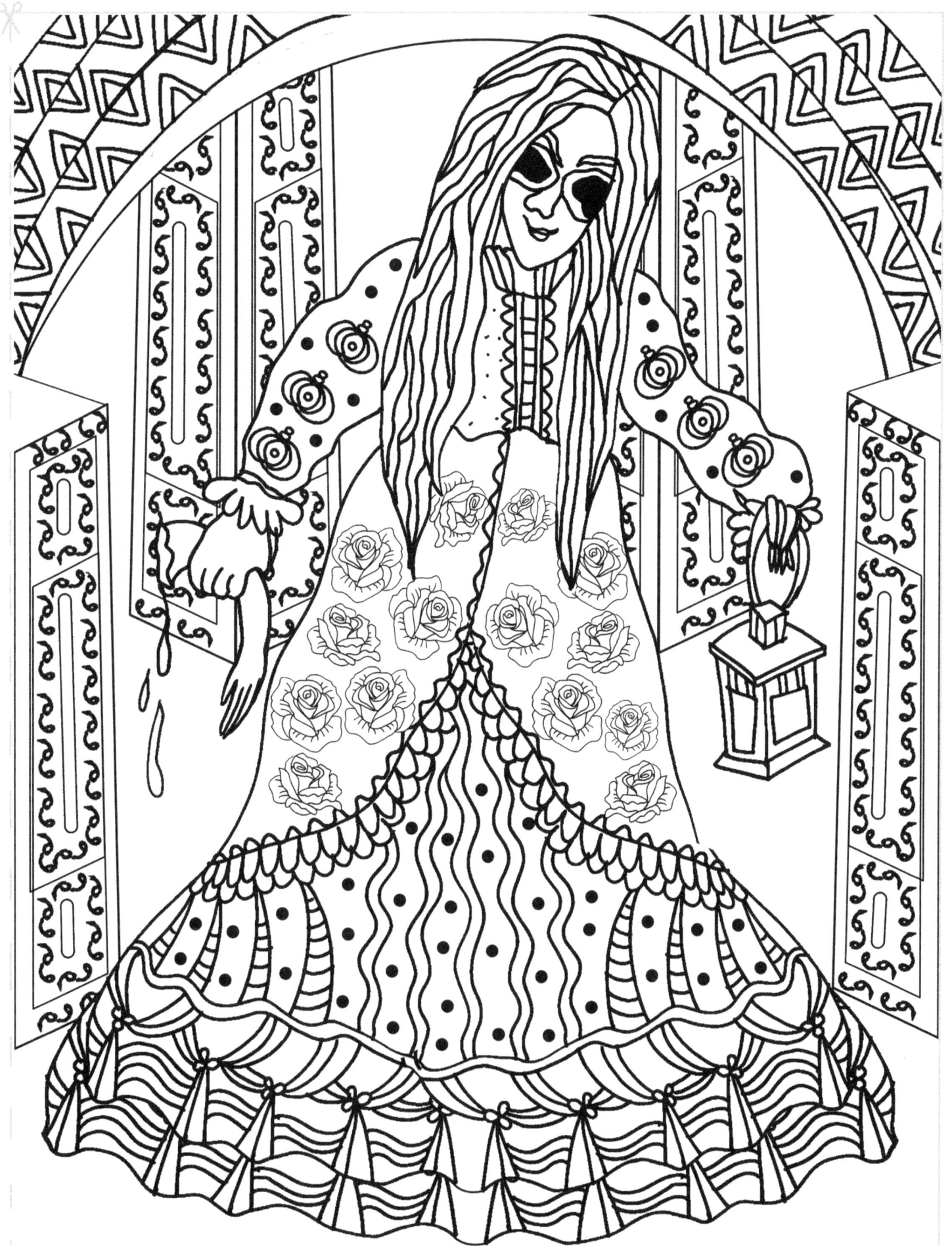

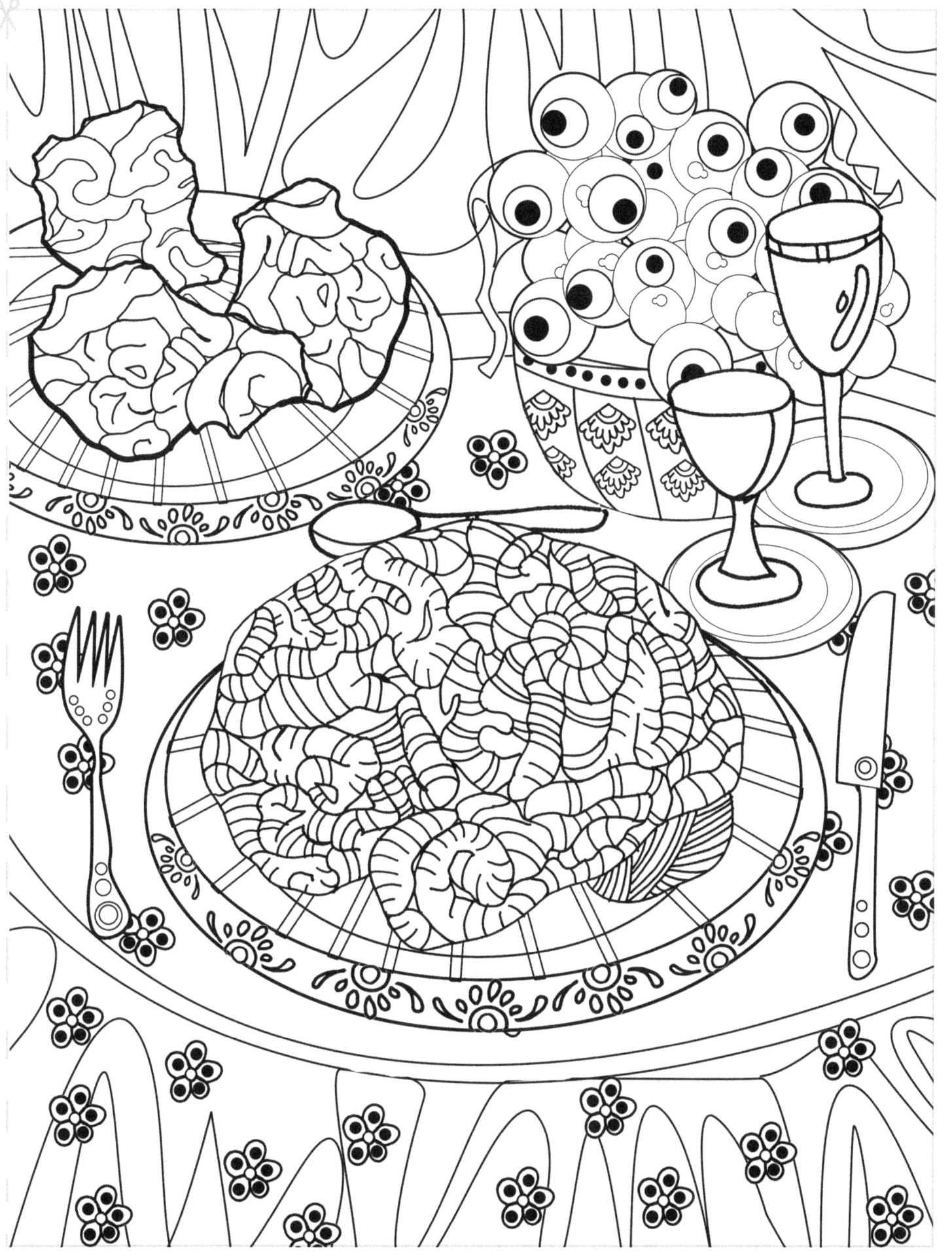

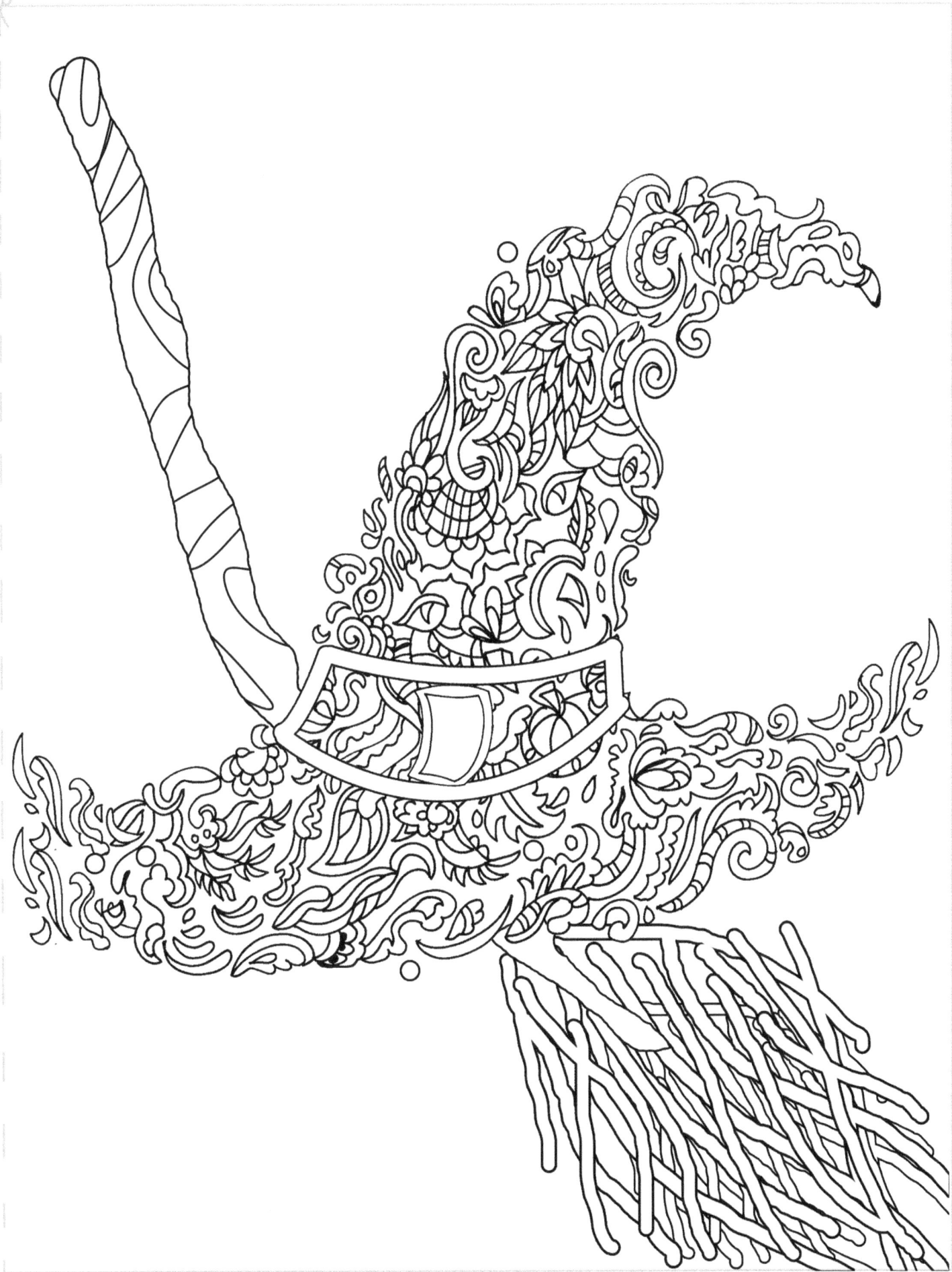

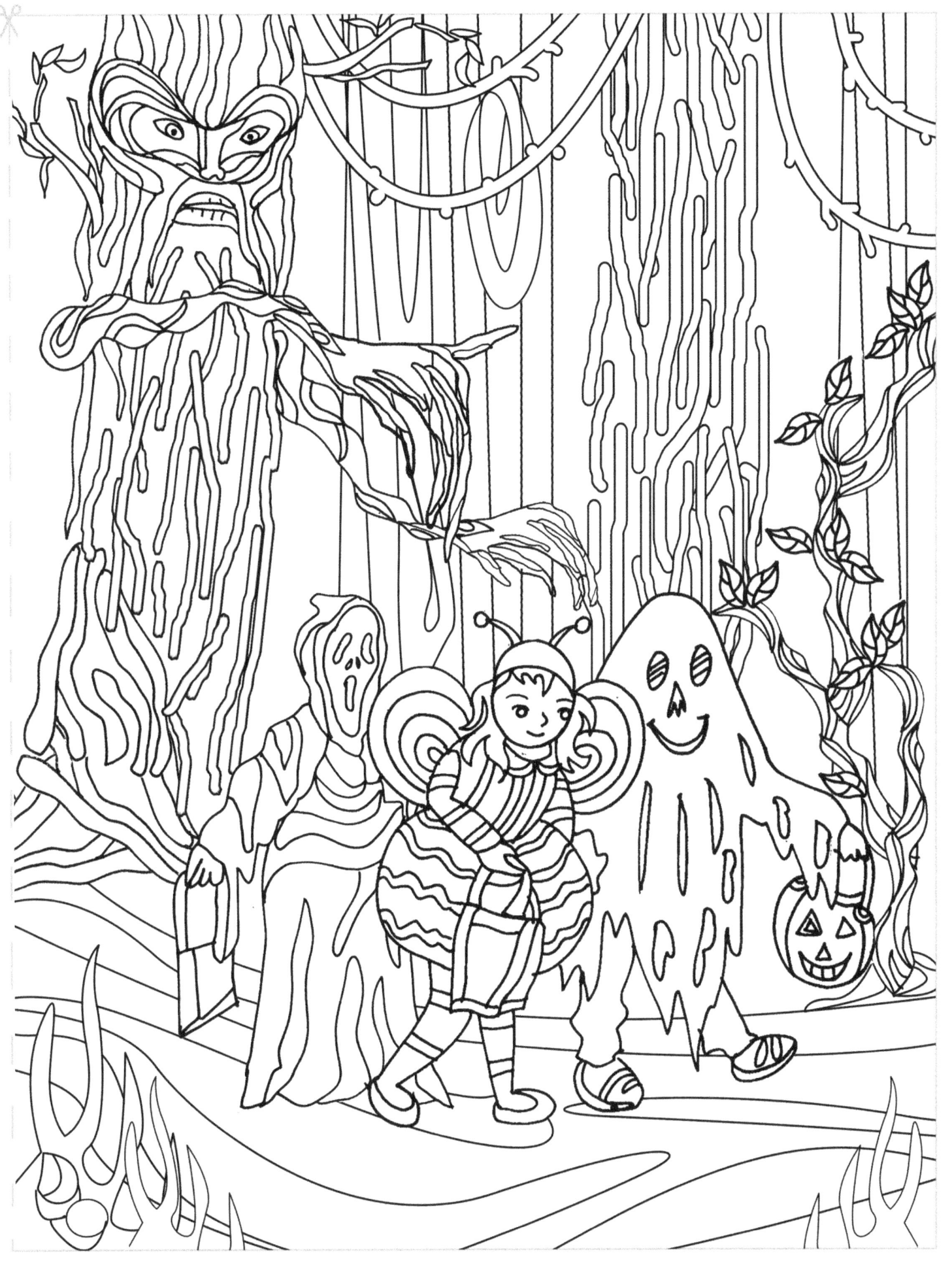

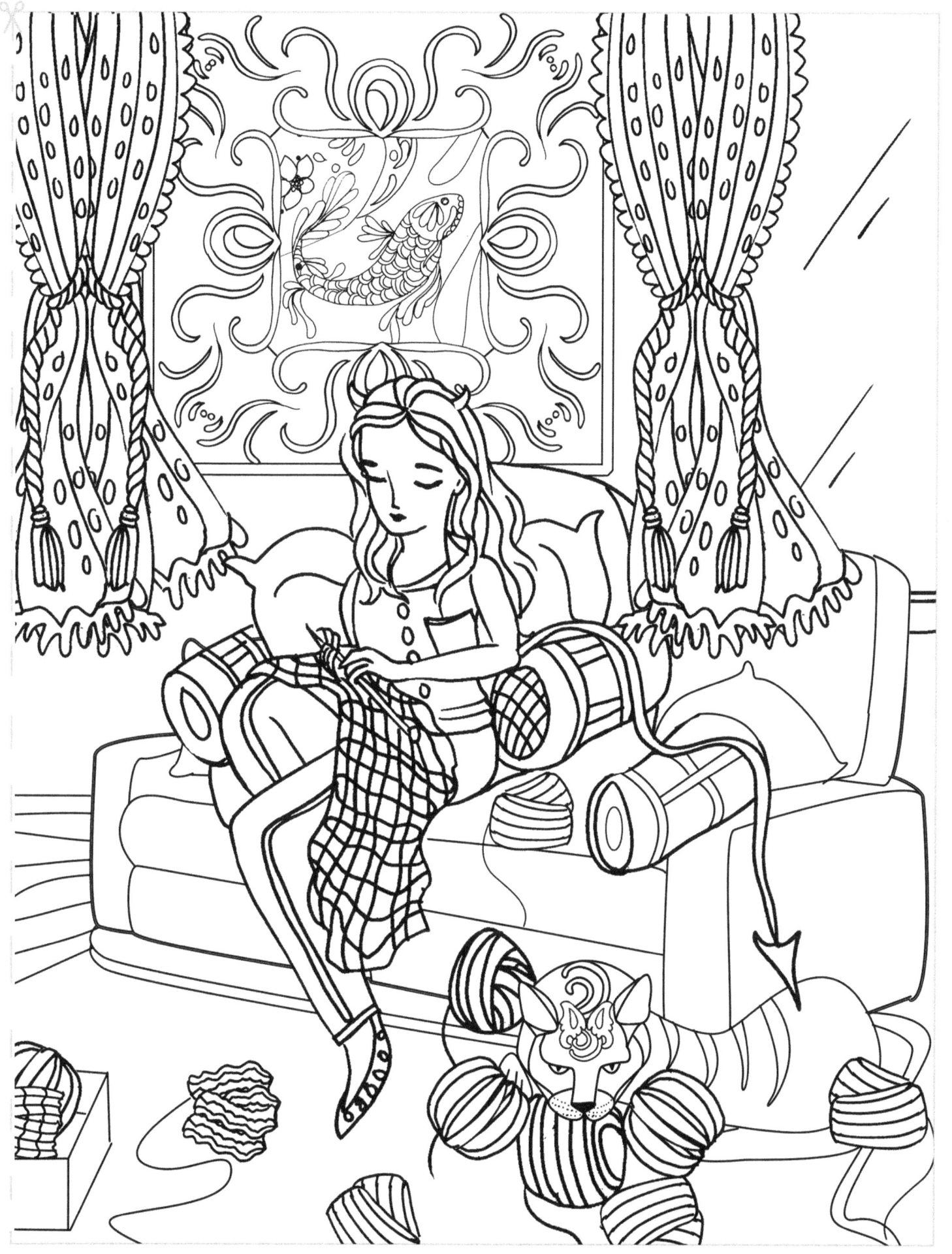

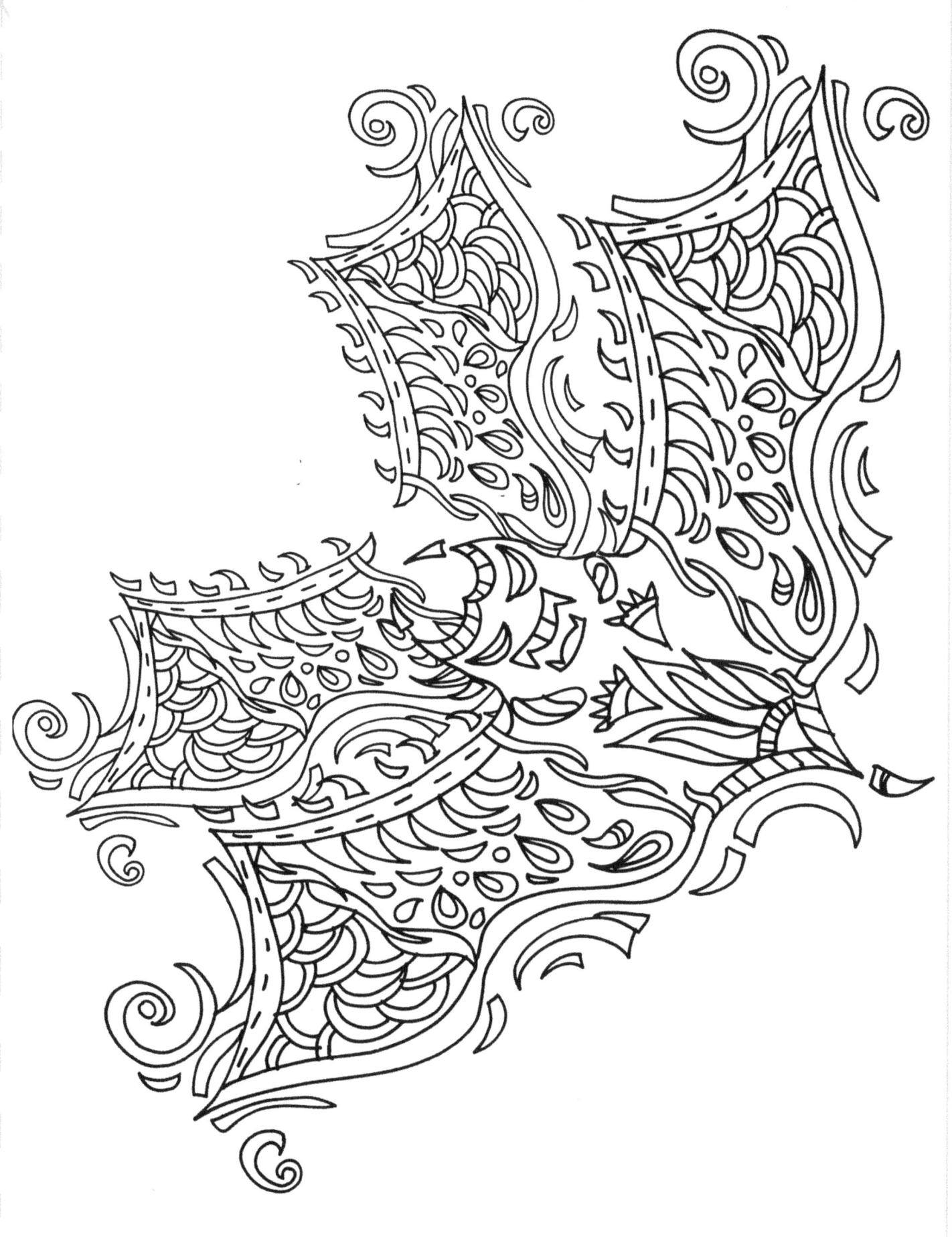

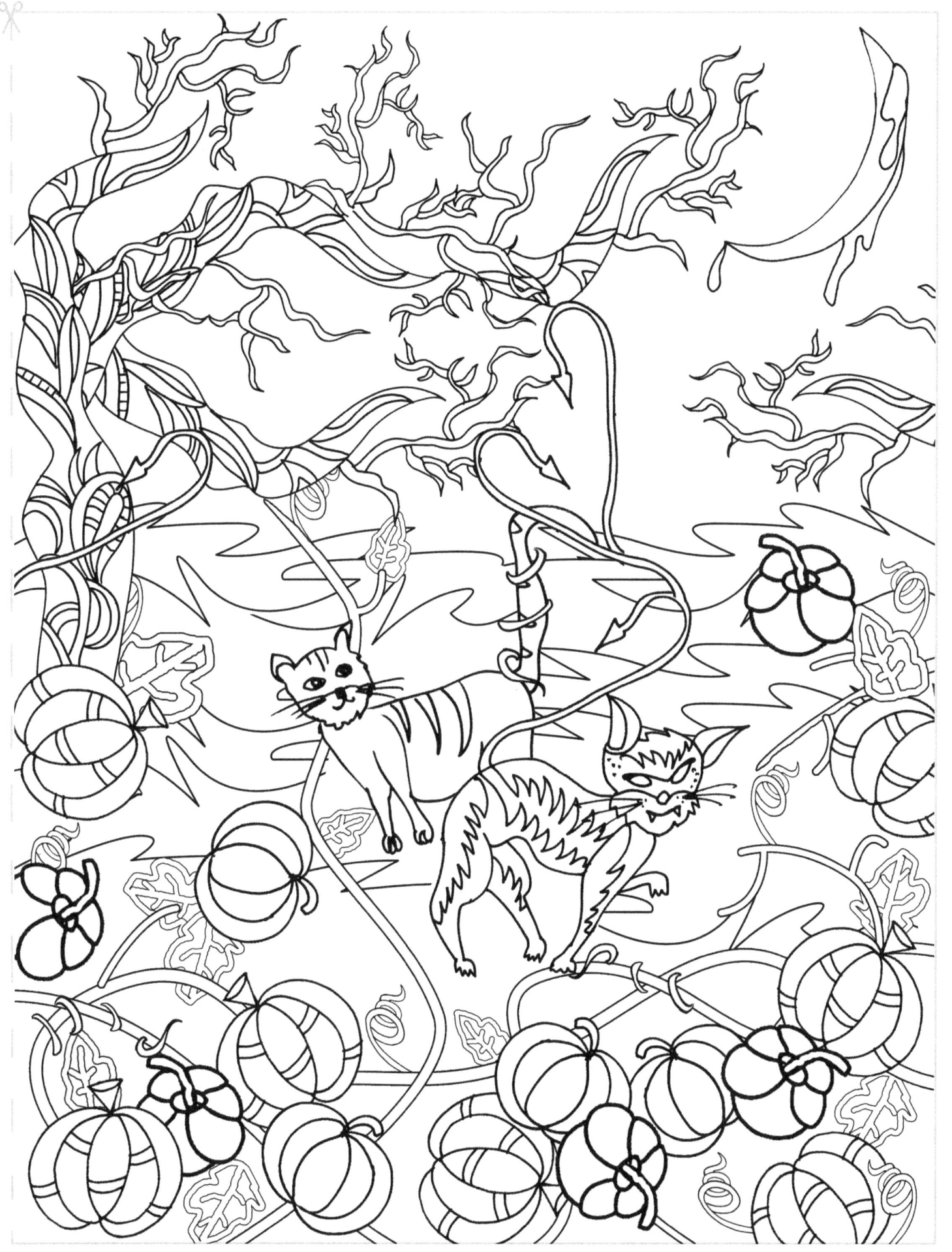

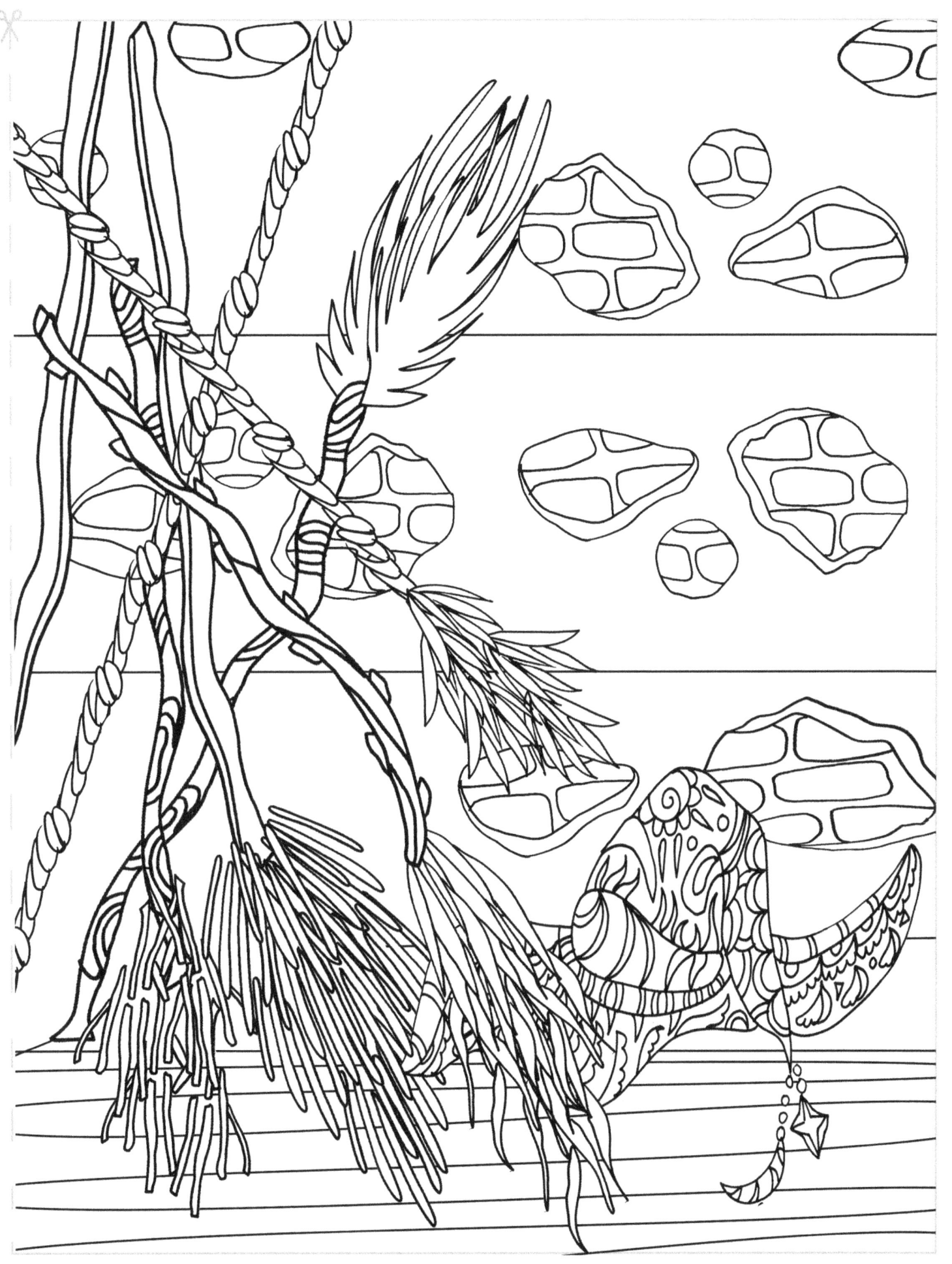

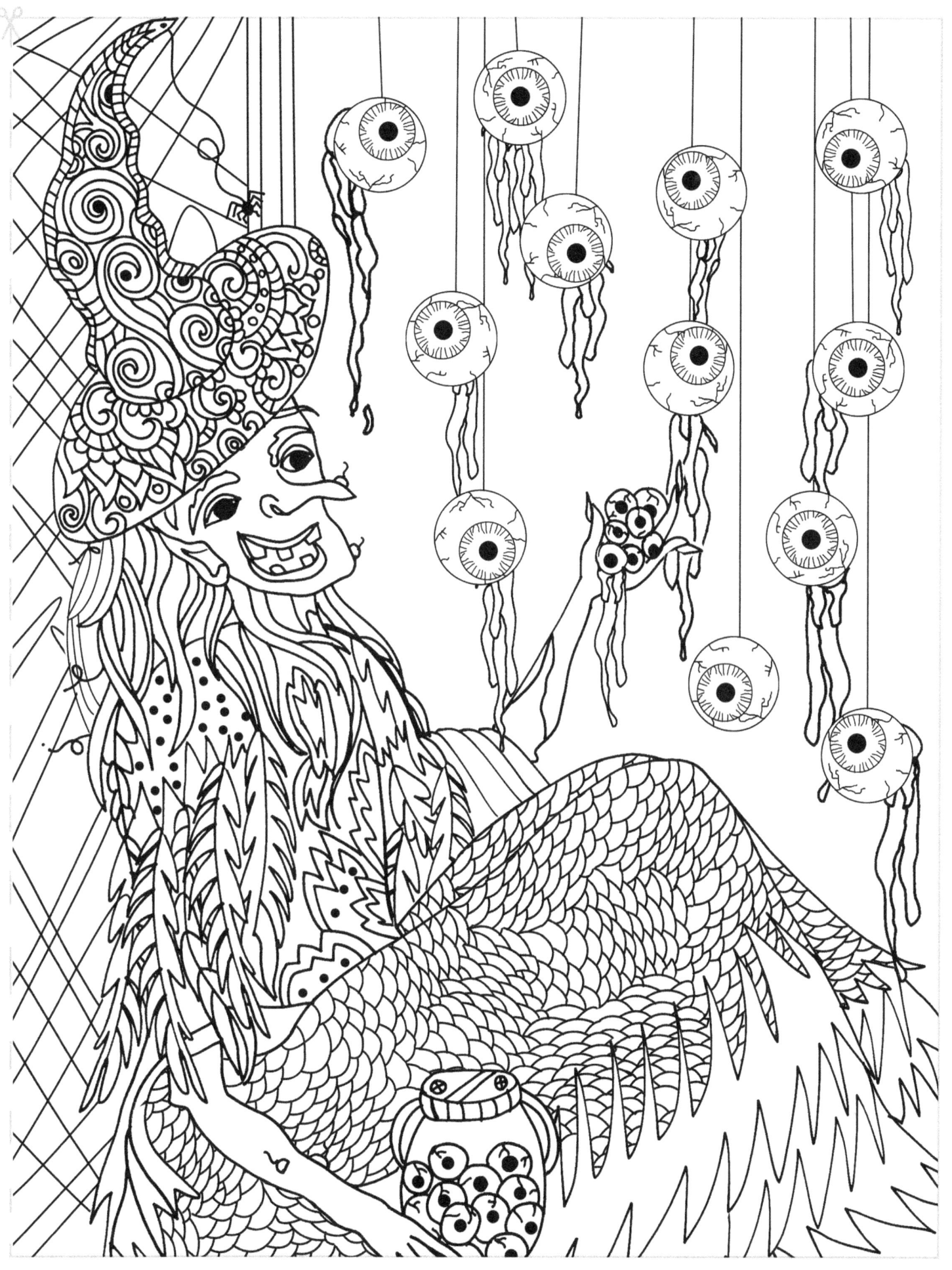

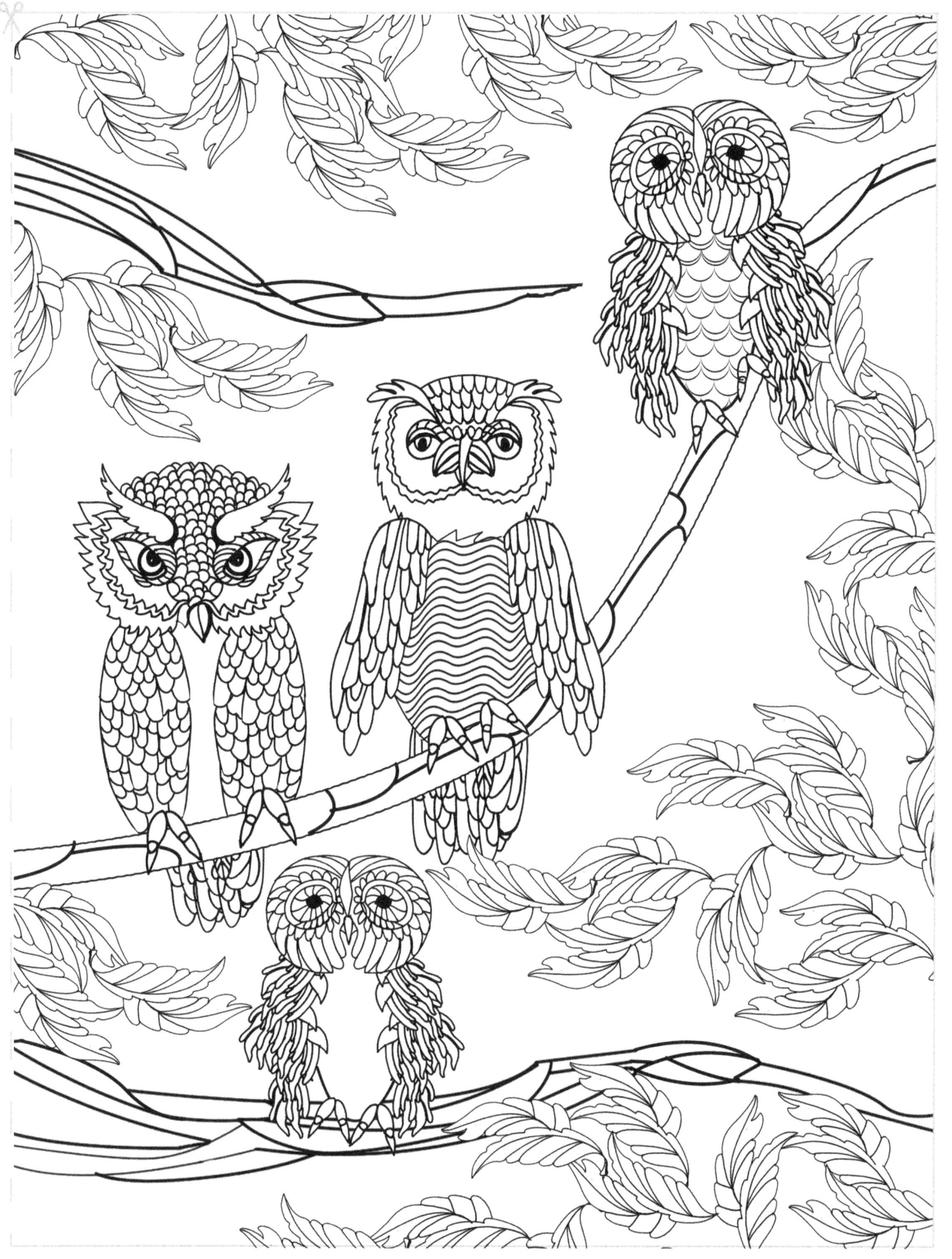

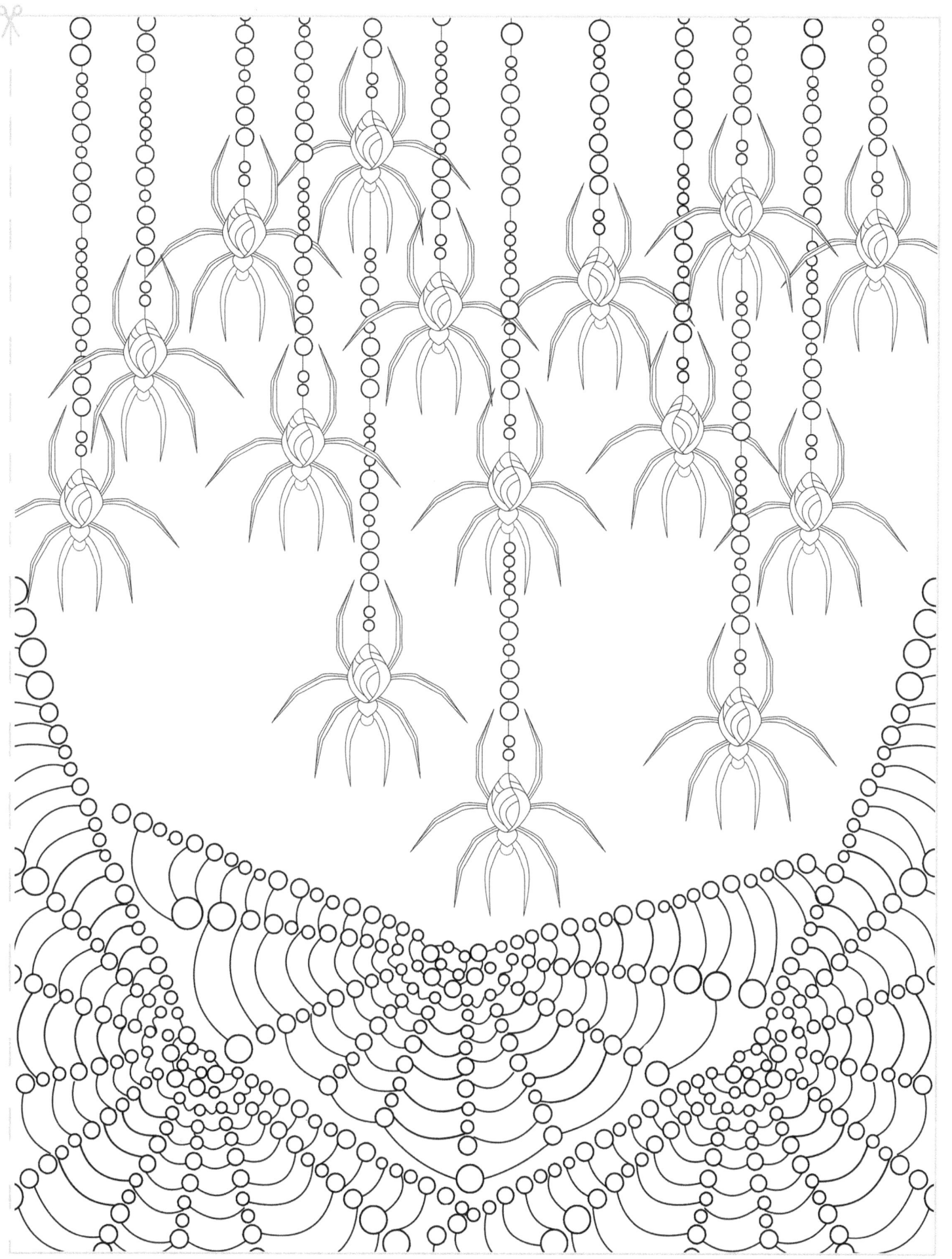

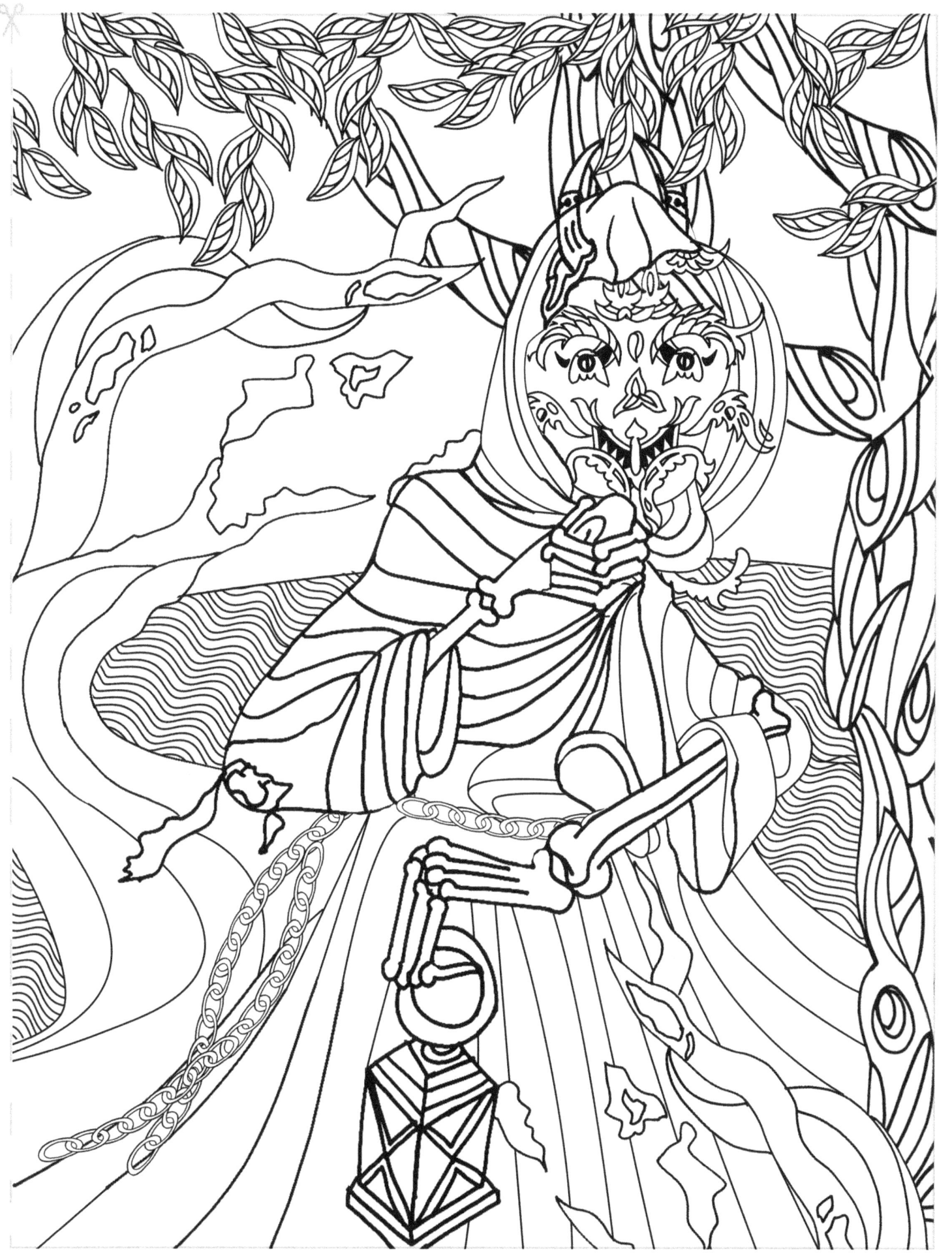

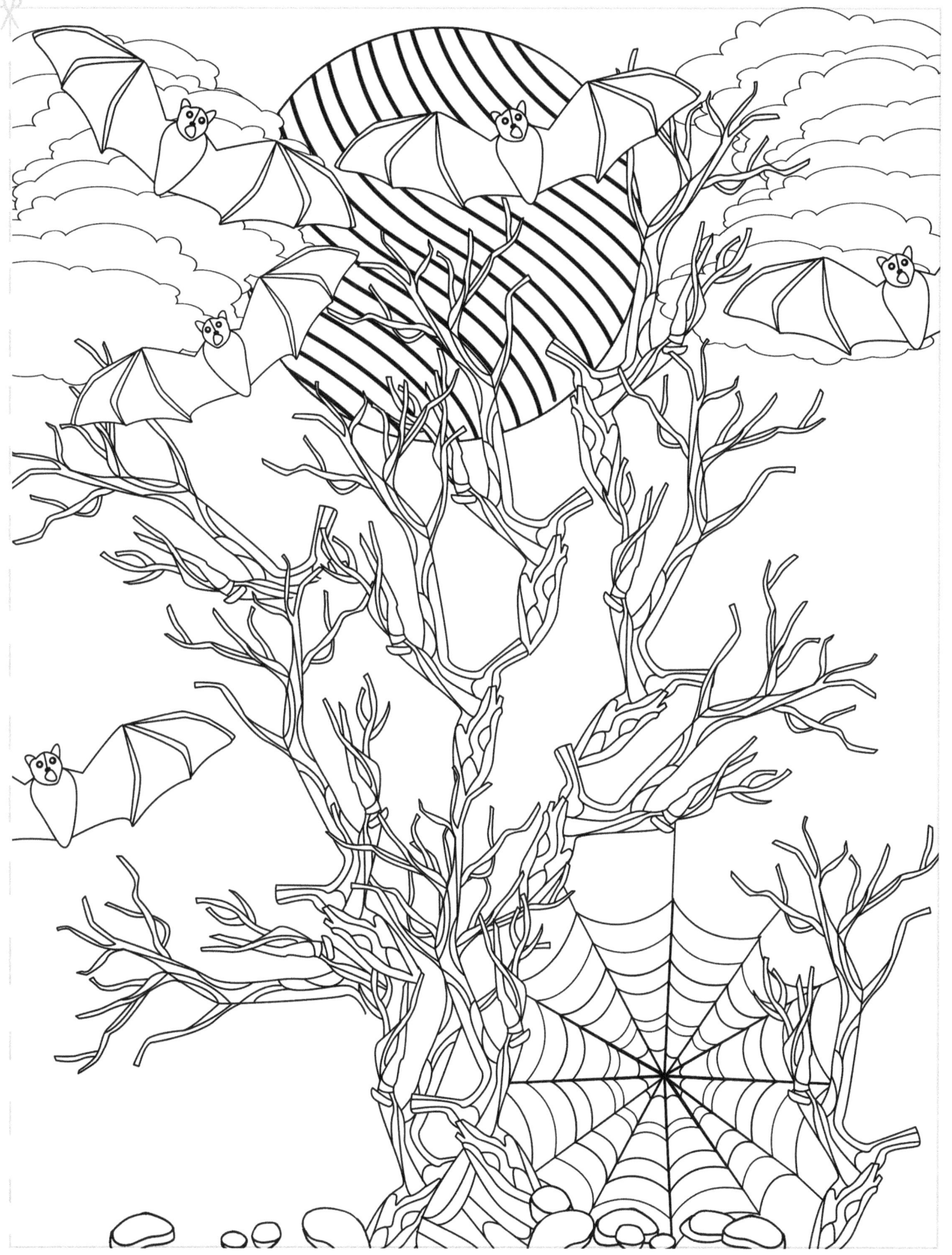

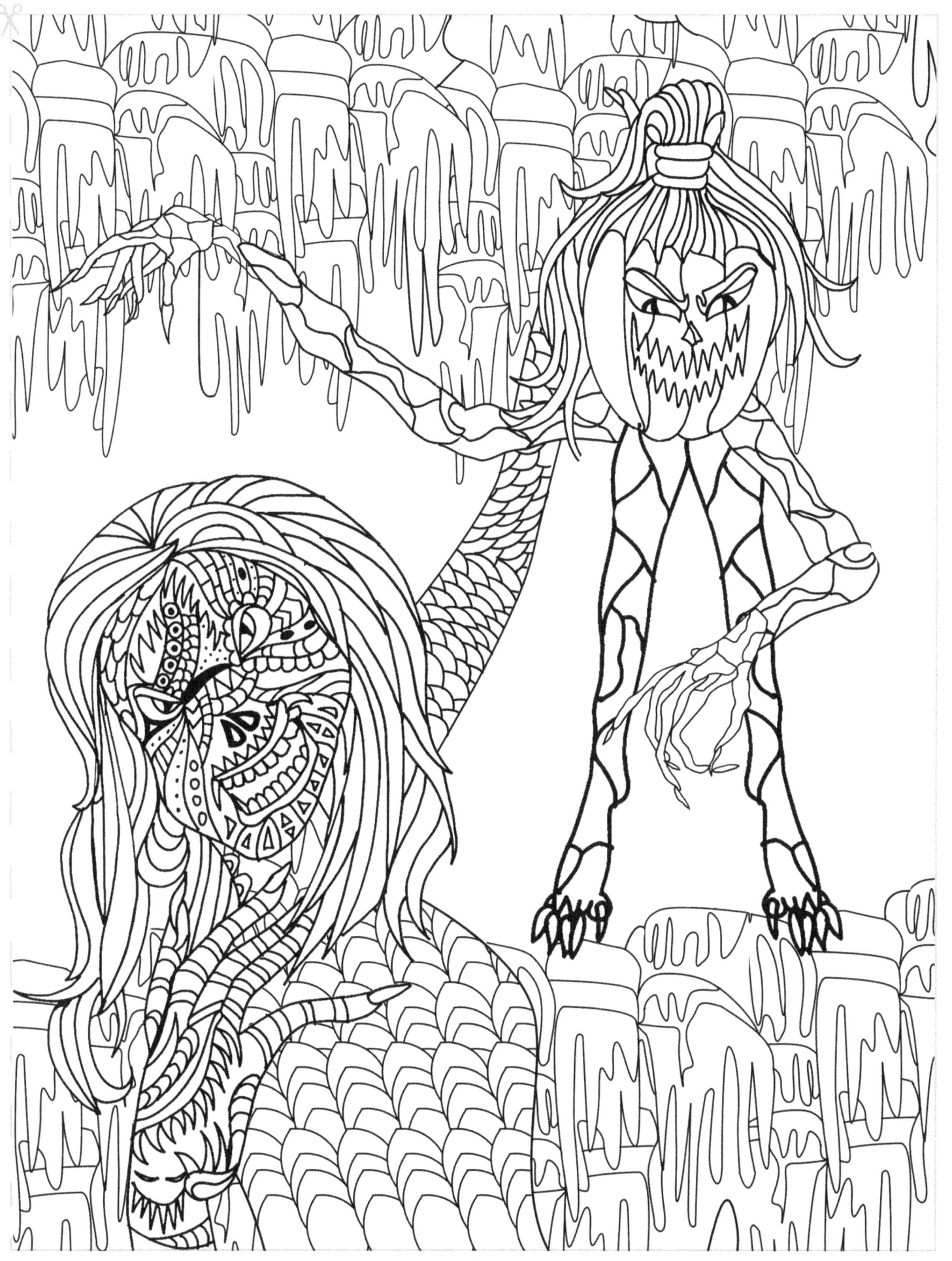

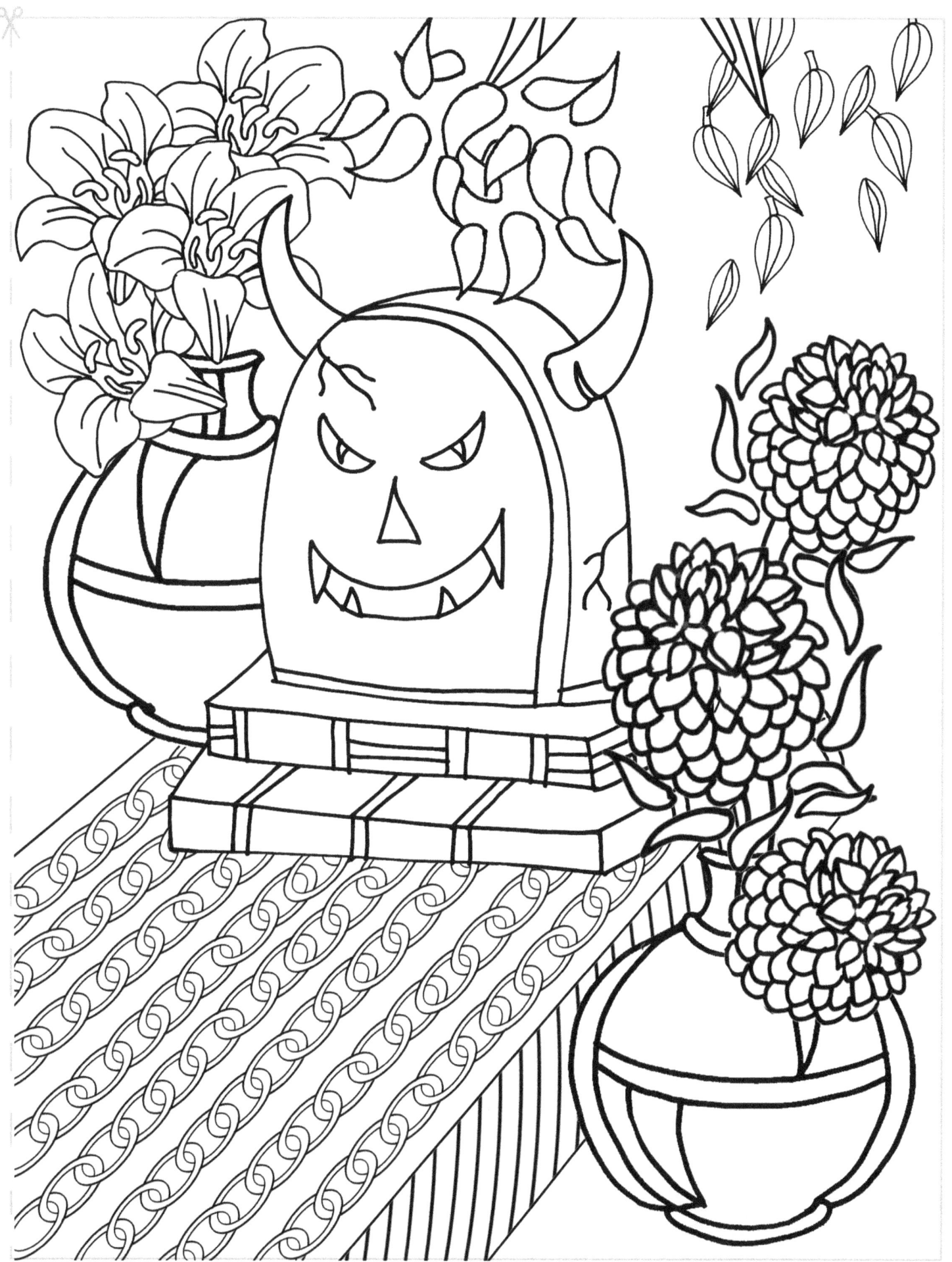

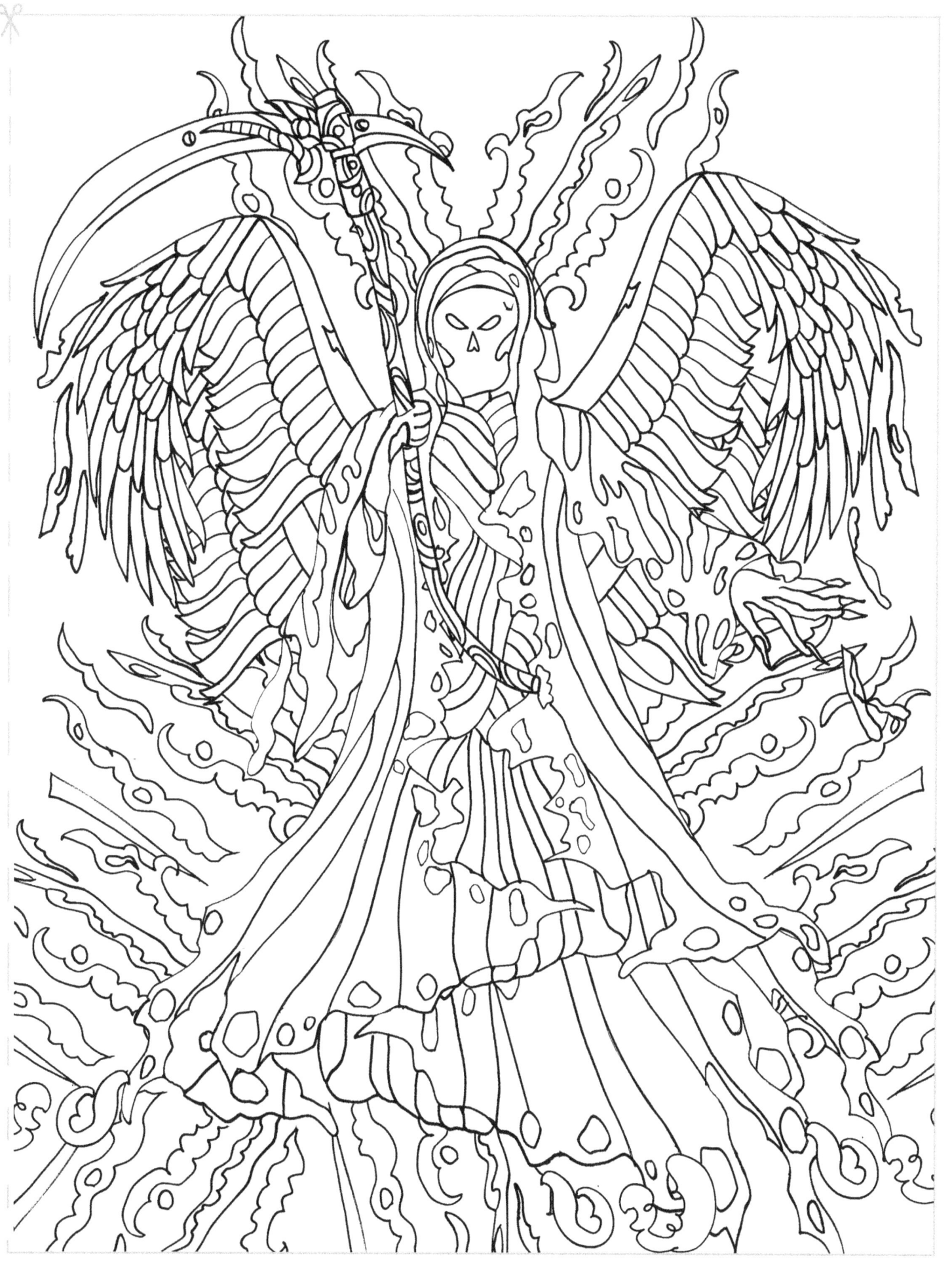

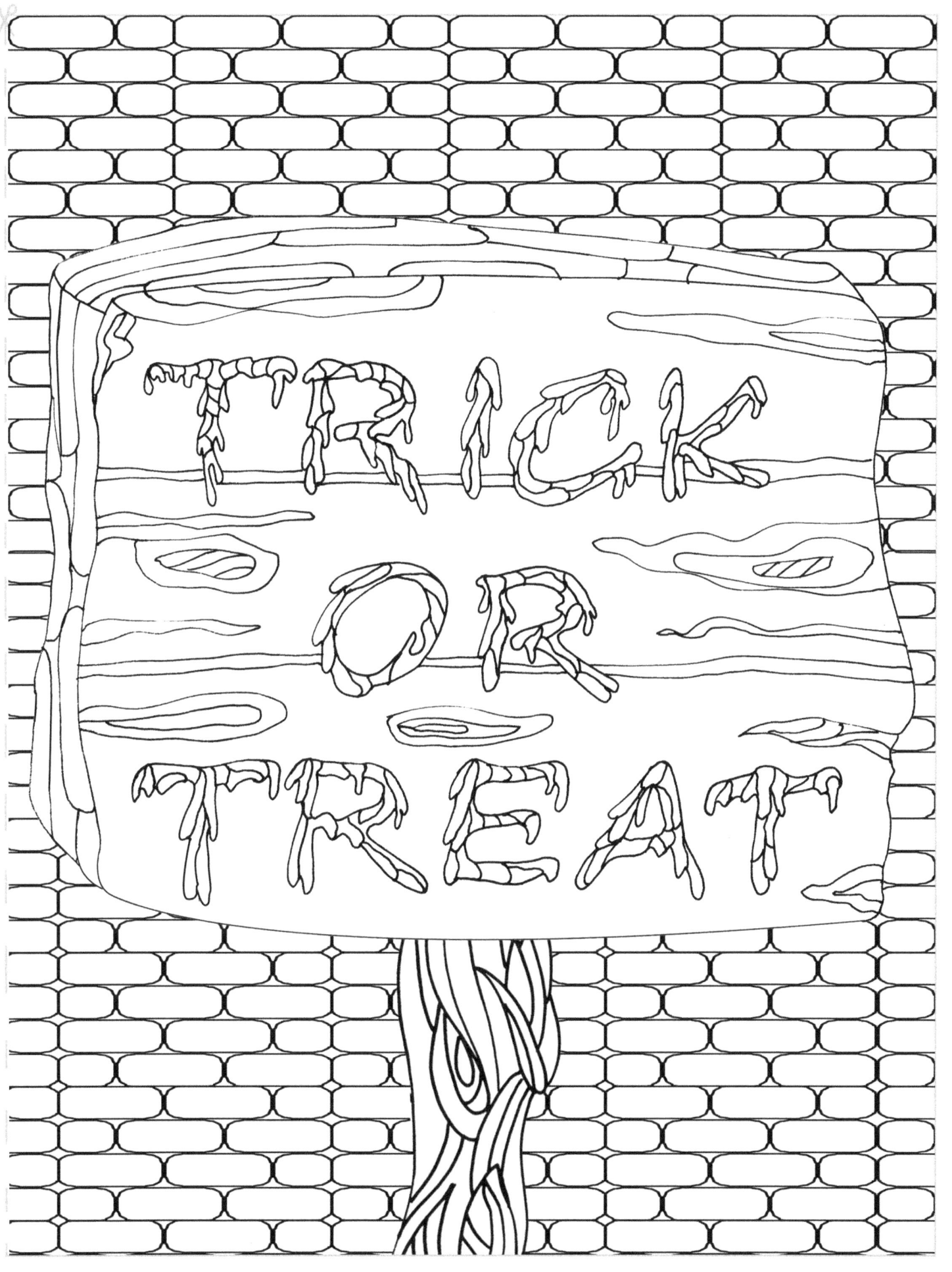

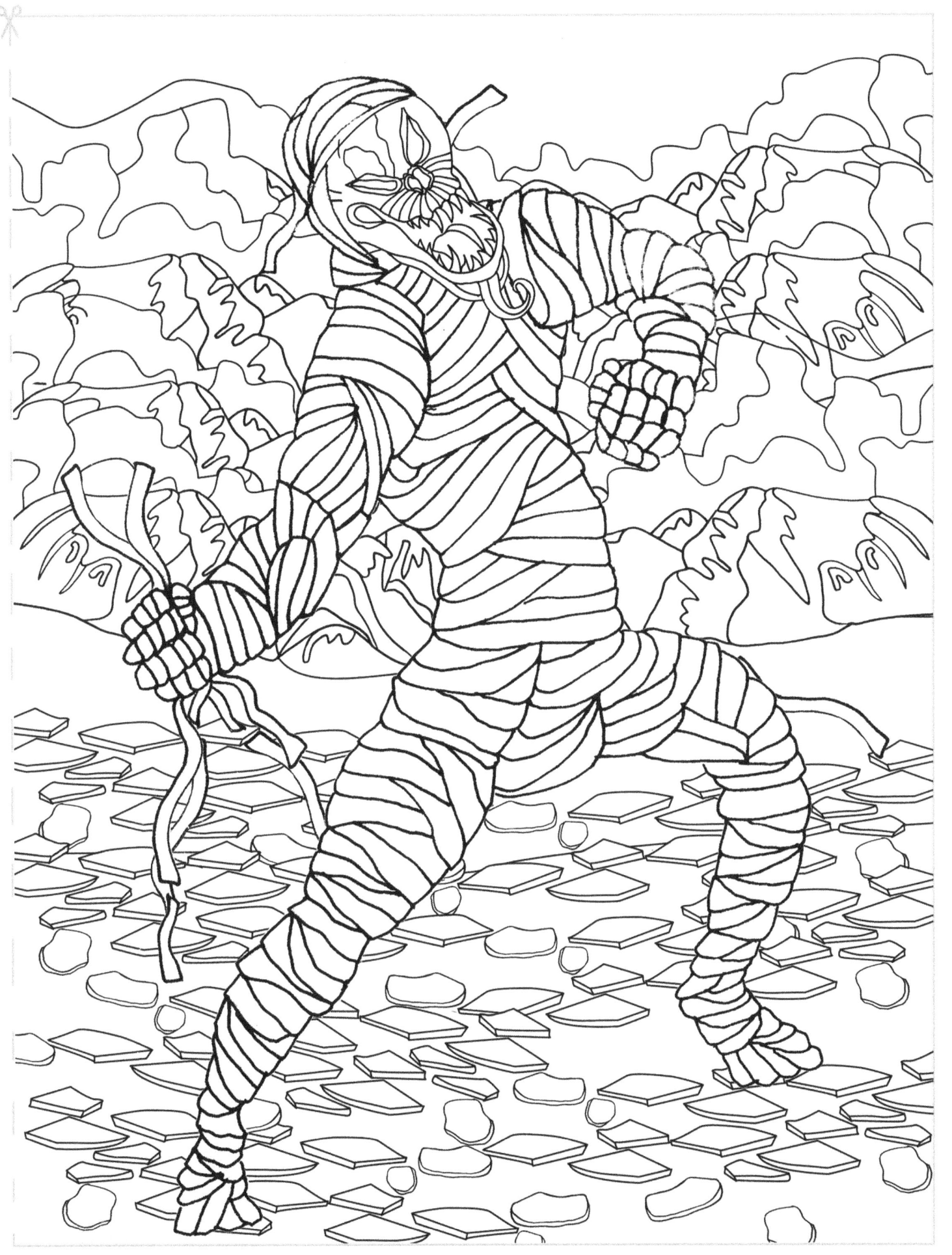

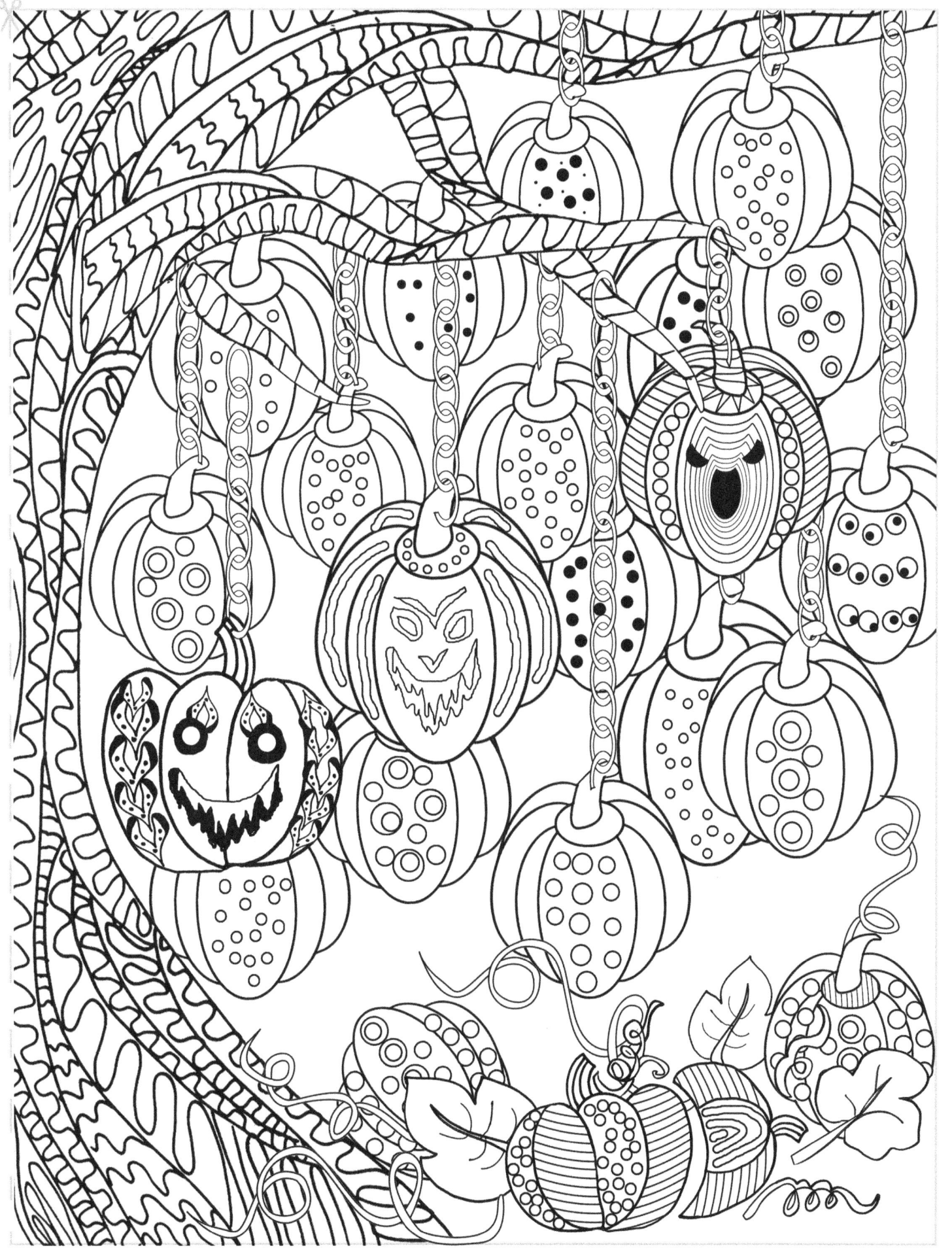

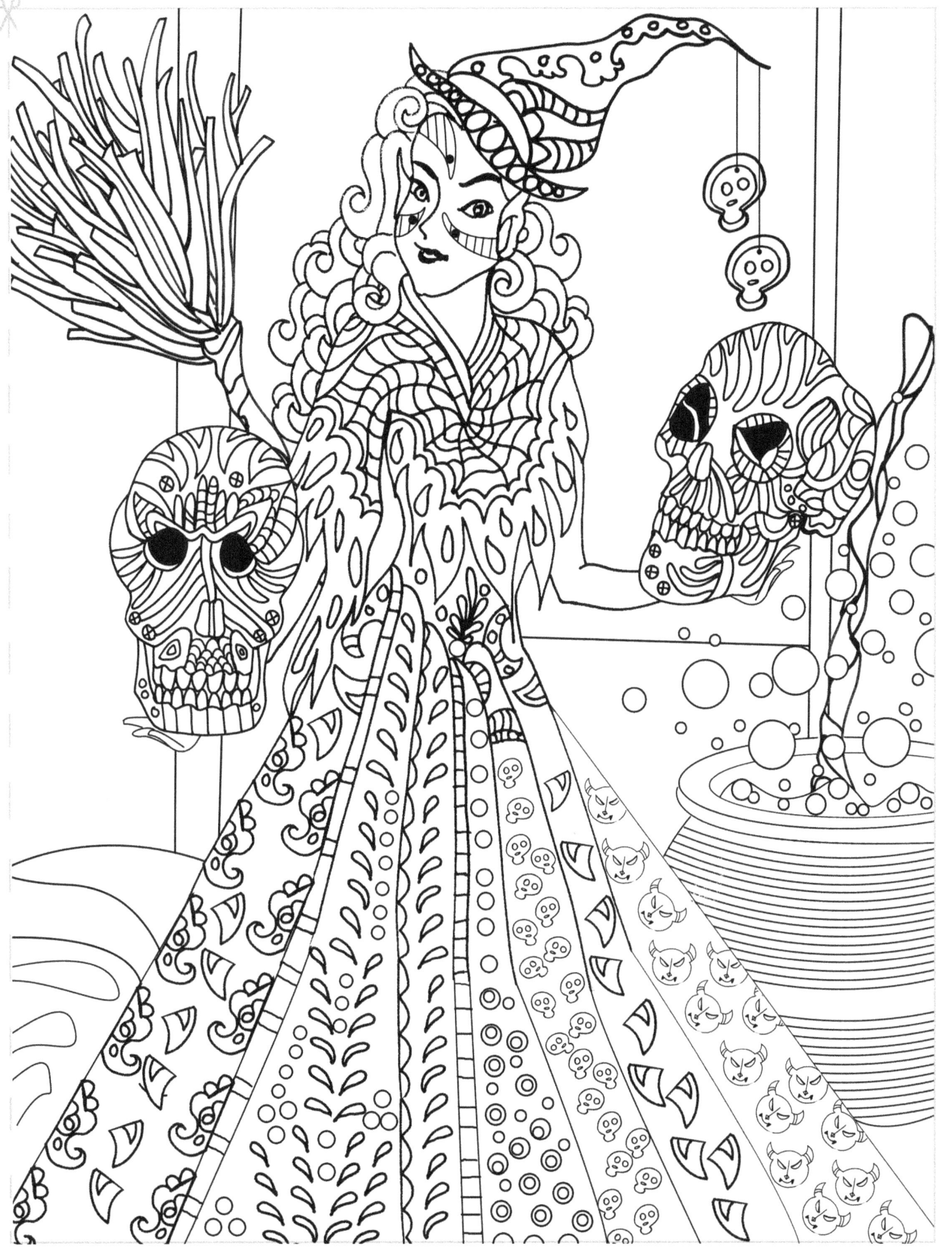

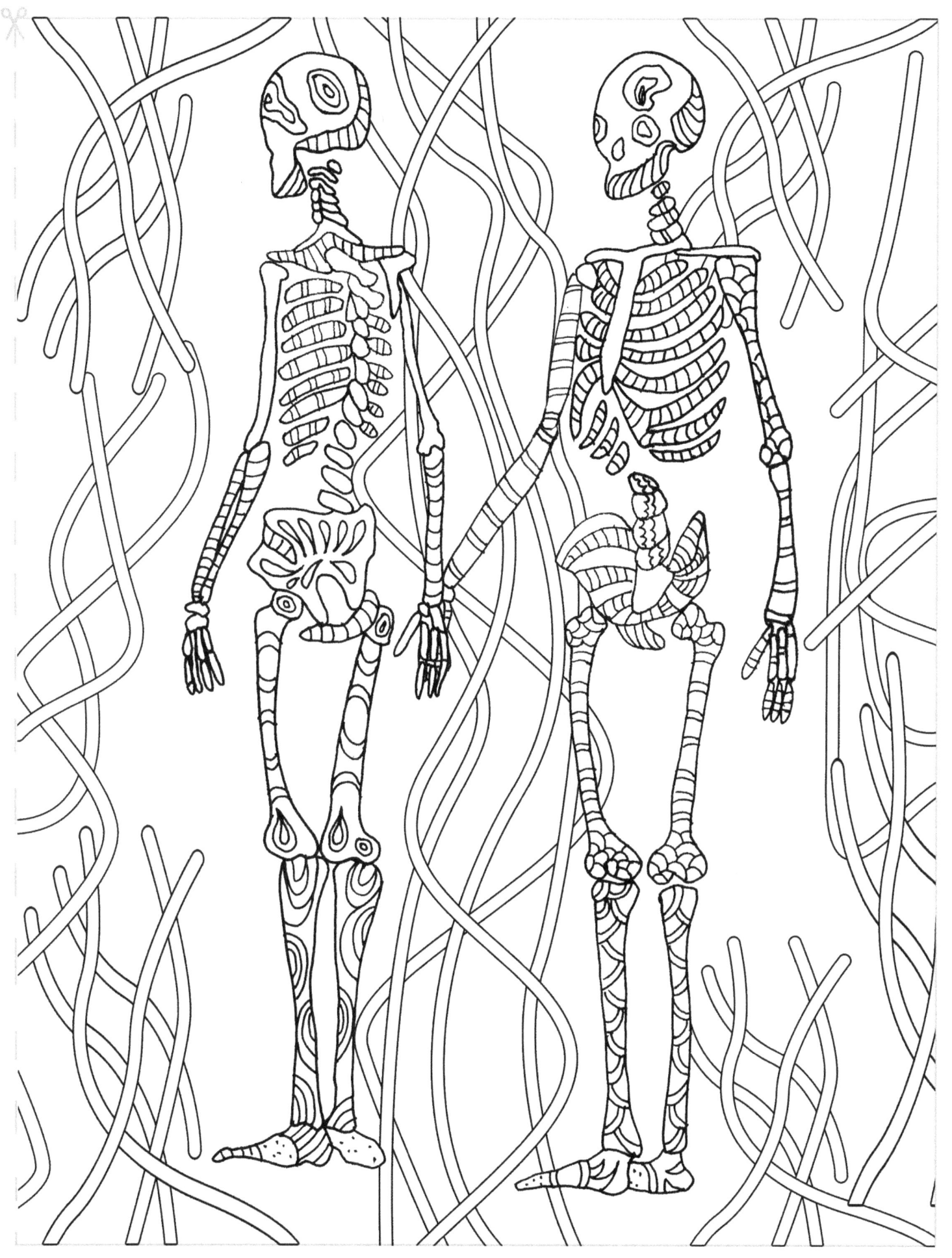

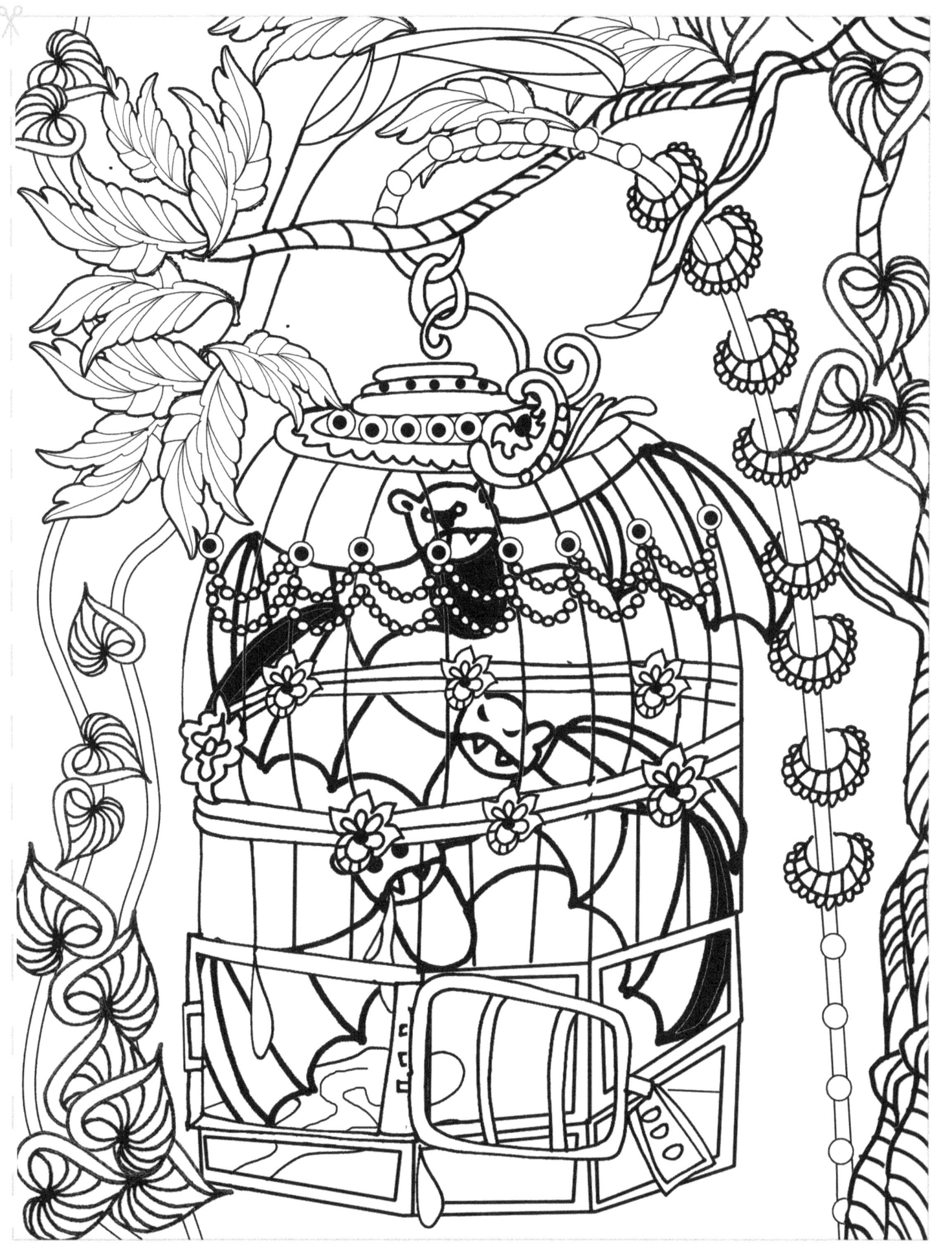

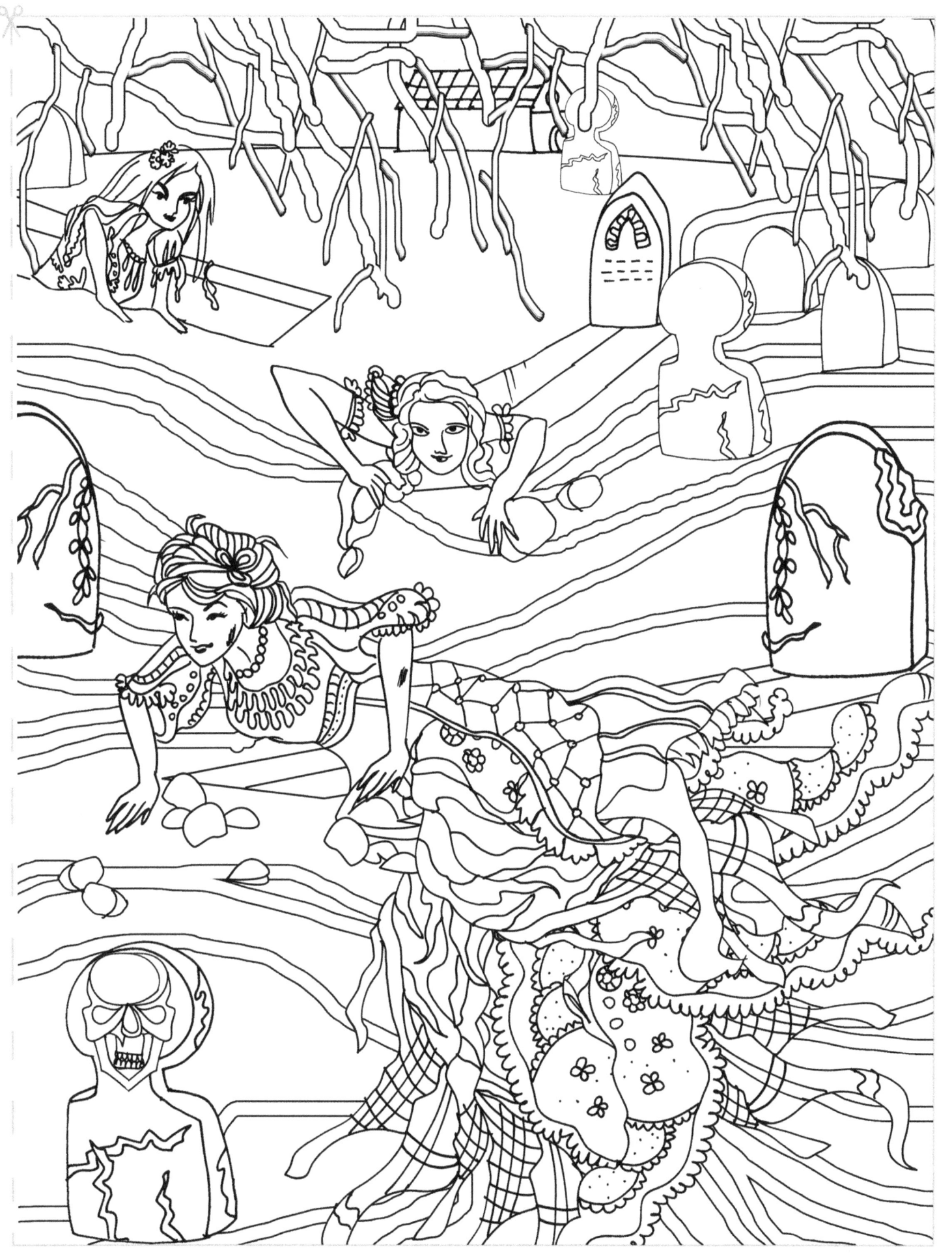

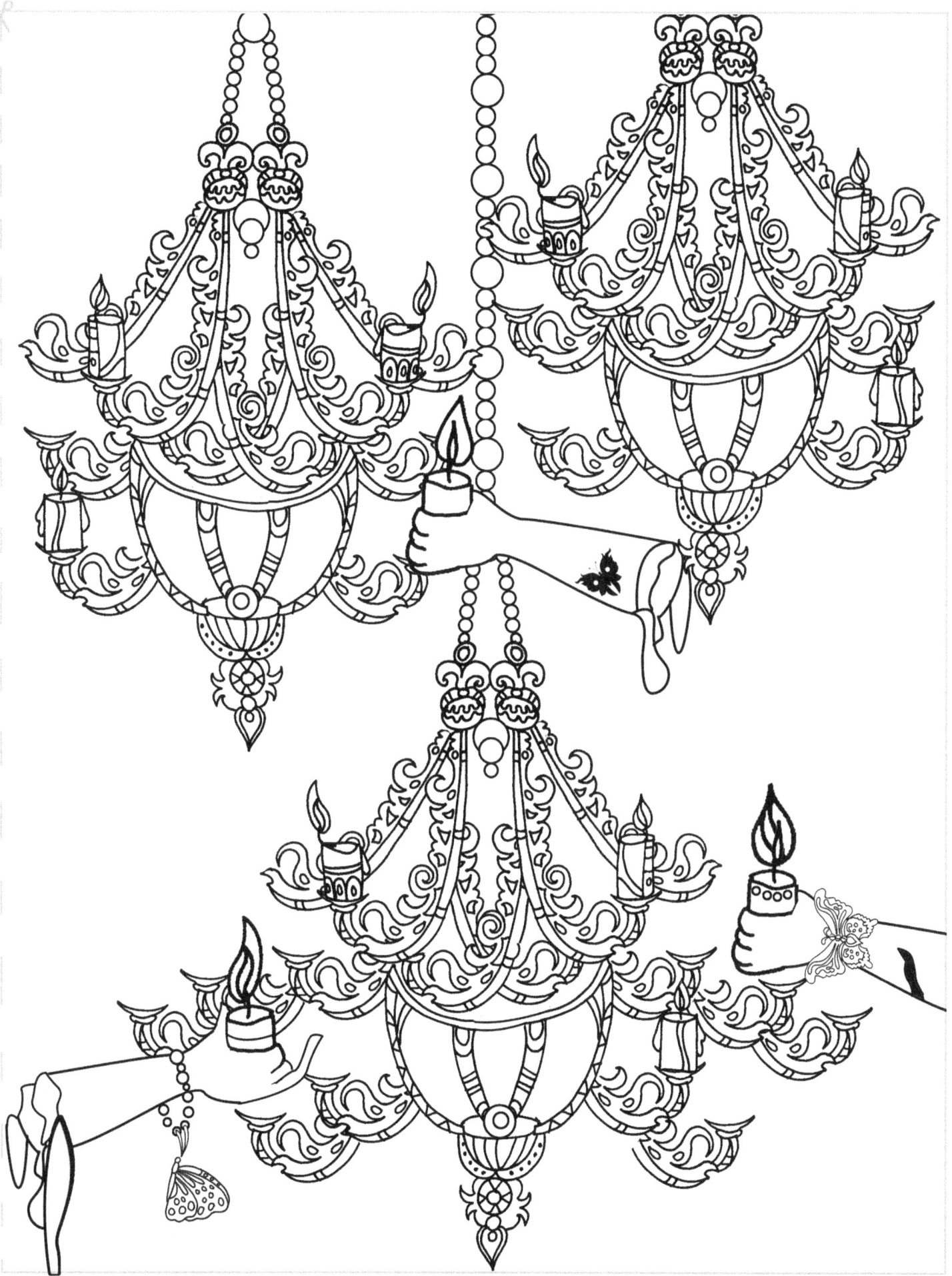

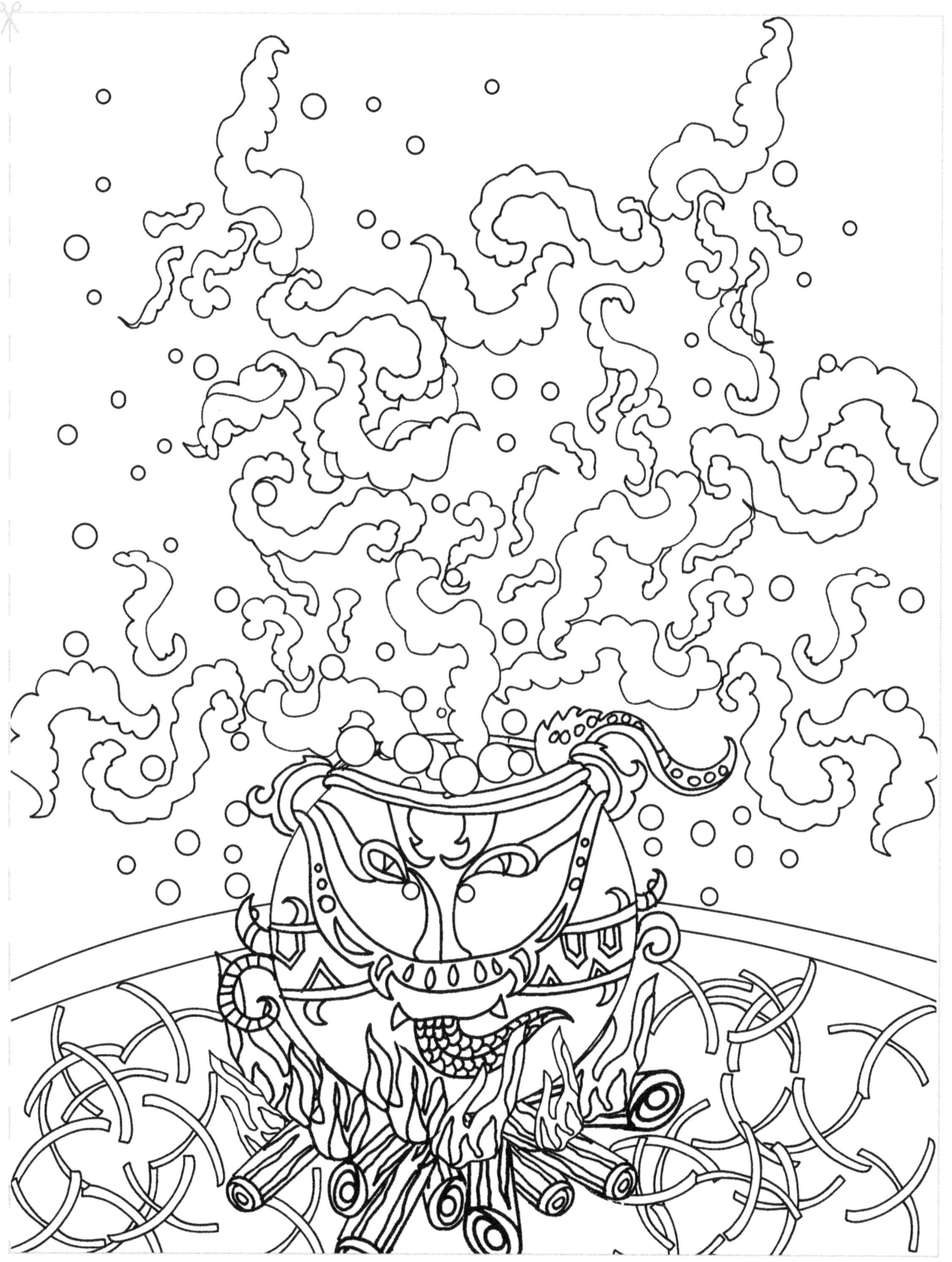

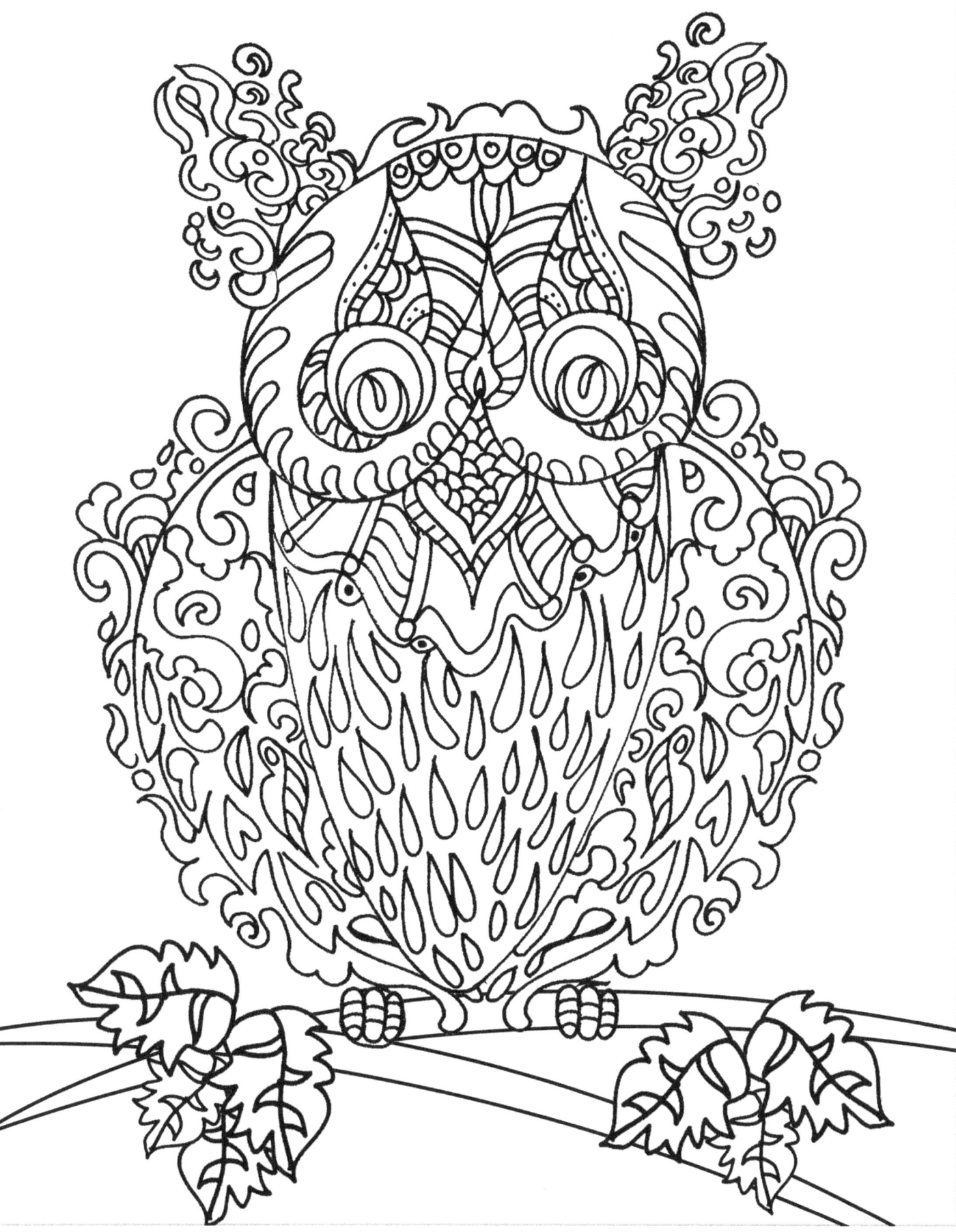

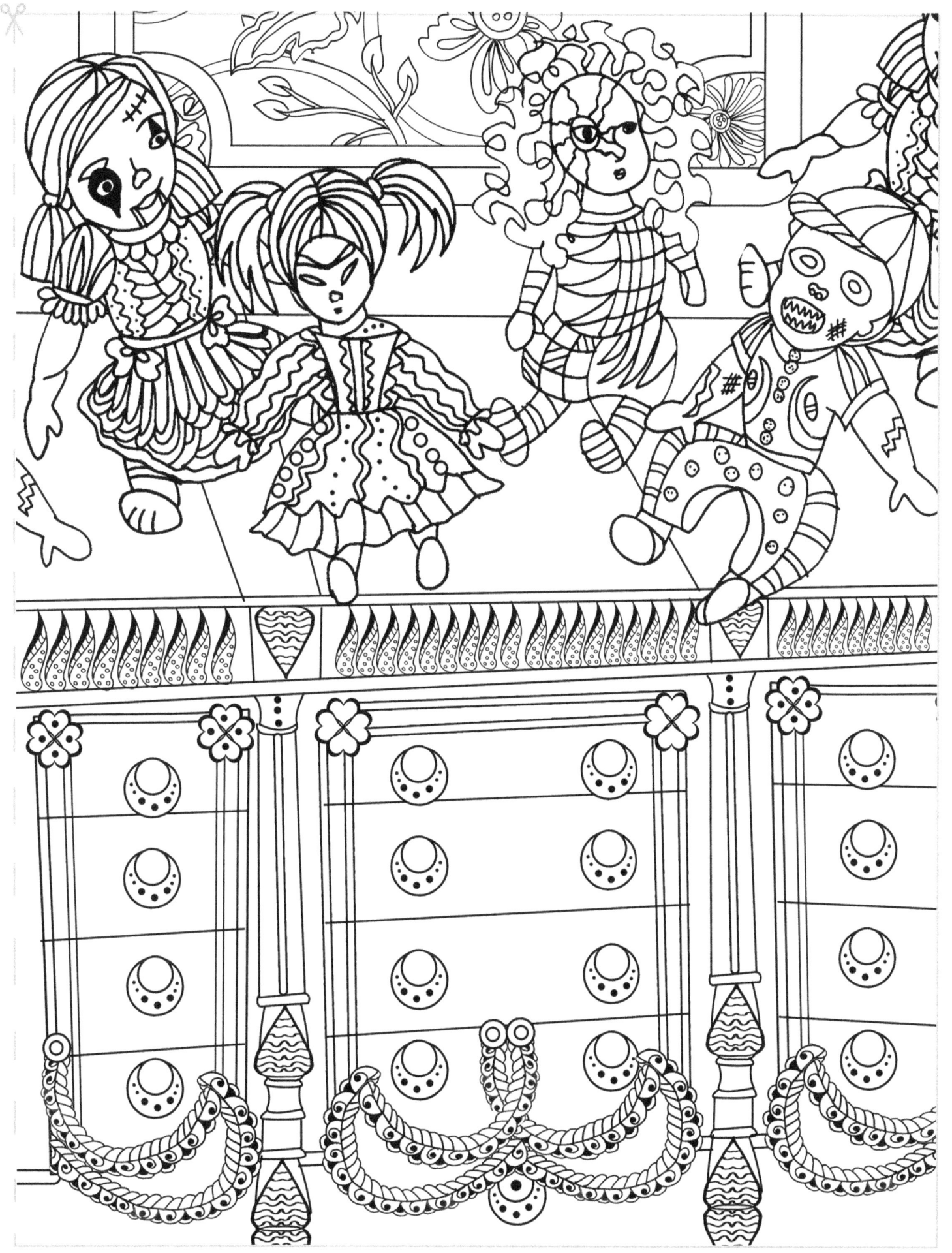

www.ingramcontent.com/pod-product-compliance
Lightning Source LLC
Chambersburg PA
CBHW080624190526
45169CB00009B/3285